WATERCOLOR
TRICKS & TECHNIQUES

Cathy Johnson

WATERCOLOR
TRICKS & TECHNIQUES

NORTH
LIGHT
BOOKS

Cincinnati, Ohio

Watercolor Tricks & Techniques. Published by North Light Books, an imprint of F&W Publications, Inc., 1507 Dana Ave., Cincinnati, Ohio 45207. First edition.

First Printing 1987

Library of Congress Cataloging-in-Publication Data

Johnson, Cathy (Cathy A.)
 Watercolor tricks & techniques.

 Includes index.
 1. Watercolor painting—Technique. I. Title. II. Title: Watercolor tricks and techniques.
ND2420.J64 1987 751.42'2 87-21952
ISBN 0-89134-221-4

Editor: Greg Albert
Designer: Clare Finney

A second book for any one publisher is always a sort of confirmation, a positive in a continuing relationship. A special warmth accompanies my thanks to those most closely involved with the production of this book. To David Lewis, editorial director at North Light, who helped shape the book into usable form; to Fritz Henning, who helped me to develop the original idea and to clarify what I did *not* want it to be; and to Greg Albert, my editor who is always there when I have a question or request—my heartfelt thanks.

I began writing for other artists when *The Artist's Magazine* came into being in 1984 with a story that was the genesis of this book; at that time William Brohaugh was acting editor, and his help was invaluable. Mike Ward, now editor of the magazine, and Greg Sharpless, managing editor, also merit a large share of thanks in helping me learn what it is we have to say to each other as artists.

The thoughtful questions and comments of my workshop participants have helped me shape this book; their input was solid gold.

And most of all to my husband Harris, whose patience and encouragement have been monumental—my thanks. This book is for you.

C O N T E N T S

Introduction 9

Part One 11

Liquid Aids

In this section we discuss all those things that go to make up the liquid and exciting nature of watercolor. These include everything from the pigments themselves to some of the old standbys—liquid frisket, India ink, opaque white, and so forth—and some bright new techniques, such as glue, soap, and even cooking spray. You'll also find samples of each technique to get you started—the how-to as well as the why-to.

Part Two 49

Dry Helpers

Of course as watercolorists we choose a paper as our premier dry helper; without the painting surface itself we'd be lost. This section covers various types of paper, from the three best-known types (rough, cold press, and hot press) to some new and different ones you may not yet have tried.

We won't stop with papers, of course, other dry helpers include salt, plastic wrap, and all sorts of exciting and challenging texturing techniques. Included also is a special section on *lifting* pigments; this technique can be a lifesaver for a painting gone wrong.

Special Tools

Watercolorists use more than brushes as their painting tools—although choosing the right brush for the desired effect can be half the battle. We'll show you the various effects possible with a variety of brushes—and encourage you to try your own brushes "every which way you can." This section covers old tools and new ones, from rigger brushes to sprayers. Paint with your brushes alone, if you wish, or try bamboo pens, crayons, even drinking straws—your own imagination is your only limit.

Techniques in Action

This section is designed to show you the tools, techniques, and tricks in action—how one artist chooses her "bag of tricks." I hope it will get you started compiling your *own* special wizardry.

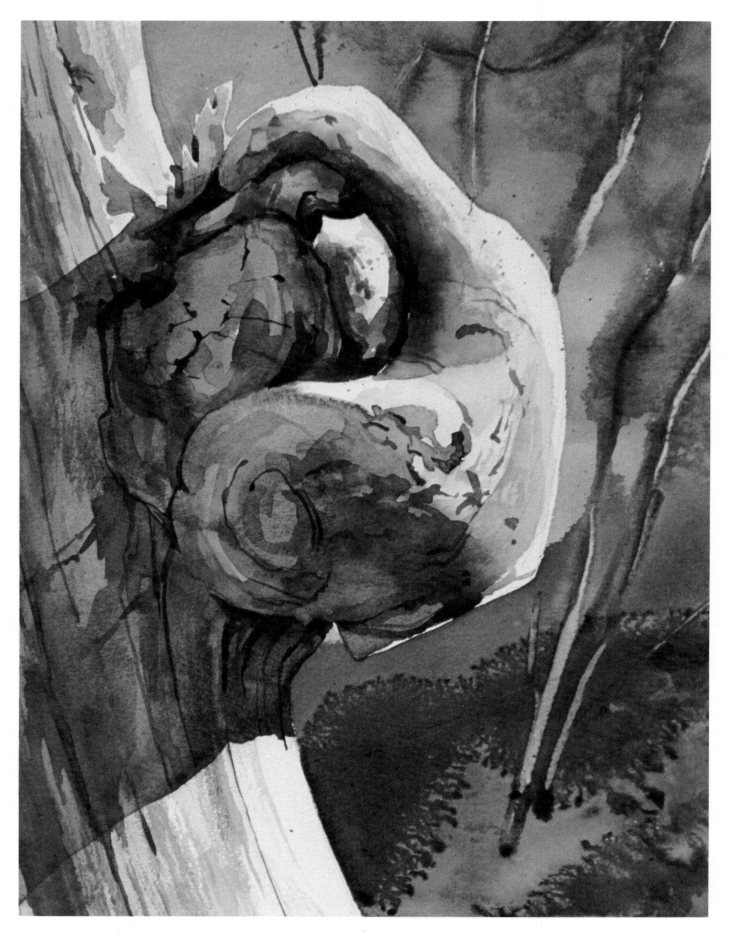

Watercolor is a wonderfully untamable medium. It's exciting, challenging, unpredictable, and fun. Oh, sometimes we may think it would be great to corral it and gentle it to our bidding, but where would be the excitement? Best just to *jump on* and ride for all you're worth.

I admit to a fantasy on those days when I've been thrown by my favorite medium once too often. I think it would be wonderful if I could find the perfect balance between technique and vision so I could express what I see and feel, exactly the way I want to. We all see a vision in our heads but it is seldom just the one that evolves on paper. I sometimes play with the thought that if I just learned enough and practiced enough I'd be able to capture that vision. Every time.

But that's not the way watercolor works; it's alive, with a mind of its own. It can do the most exciting things; things I never dreamed of or dared hope—these are the "happy accidents."

It's also not the way human nature works, at least when it's operating somewhere near capacity. I may *think* I want control, predictability—perfection!—but I don't. Not really. I'd stagnate and become bored. And my paintings would show it.

You may have fallen into a rut. Some time back, "my" brand of watercolor paper, imported from Italy, was discontinued. I was at a loss for a while, frustrated and angry. I could *paint* on that stuff. I knew what it would do. I knew its surface, its texture, its sizing. I knew just how much it would buckle under a wet wash. And I loved it.

But as luck would have it, I was forced to experiment, to try new things, new surfaces, new effects. I tried Japanese rice paper, rough and hot press paper. I learned my way around a variety of paper surfaces and learned just what I could expect of each. I had enlarged my repertoire. I had grown, in spite of myself!

The book is divided into four sections: Liquid Aids, Dry Helpers, Special Tools, and Techniques in Action. In the first three sections I have explored the various techniques in a number of ways; I've made very little attempt here to create "art" because I wanted to avoid the possibility that you might see the technique in my way and my way only. I've tried to keep the samples open-ended, as broad and varied as possible; then in the last section you will see how I have chosen to use some of the techniques in my own work.

Tricks vs. Technique

Of course, tricks are no substitute for solid technique and basic skills. You'll still need hard work and planning to produce a work of art. You'll need to learn how to handle your medium and how to express yourself in your own way. It's an instinctive process, a product of the right side of your brain—your creative subconscious. It is learning how to *see* as well as how to paint. It is discovering what it is that excites you about the world you live in, and learning step-by-step how, with your paints and brushes, to make that special reality live for you. There's no shortcut for that. Special techniques are only there to help you see and react in new ways.

One word of caution: it's easy to get carried away with a good trick—or a bundle of them. Not all the tricks in your bag should (or even *can*) be used together at one time. Pick and choose carefully, with restraint.

Saran Wrap can be a useful tool for texturing; used with care and discernment you'll find it exciting and satisfying. But at a recent art show I saw all too many paintings that were simply a pool of pigment textured with plastic wrap. The artist named them, framed them, and that was that. It's too easy—for my taste, anyway.

When a trick becomes "tricky"—facile or obvious, flashy or too universal—it detracts from your painting. Save your "ammunition" and use it where it counts.

Eventually you'll settle on a handful of tricks or special effects that fit your personality or approach. For the purposes of this book I used several that I normally don't use. Others I save for special occasions when only the perfect trick will do. For example, I used sepia ink drawn into a wet watercolor wash in this small painting, "Tree Gall." The delightfully unexpected, uncontrollable line *suggests* the litter of sticks and leaves on the forest floor without distracting from my subject, and without my having to paint each and every detail.

In the last section of this book you will see some tricks—my personal favorites—used more than once; others may not appear at all except in the sections where they are discussed. Although I included rough paper in the section on "Dry Helpers," for instance, you won't find a painting done on this surface. I don't *like* it; rough paper has a mind of its own, and so do I.

What you will see are a variety of paintings that reflect my own use of special effects. The effects you choose may be entirely different; that's what makes watercolor the fascinating medium it is.

Have fun. Experiment. Create. Break out of your rut, if you've fallen head first into one. And then enjoy the challenge of incorporating *new* techniques into *your* technique.

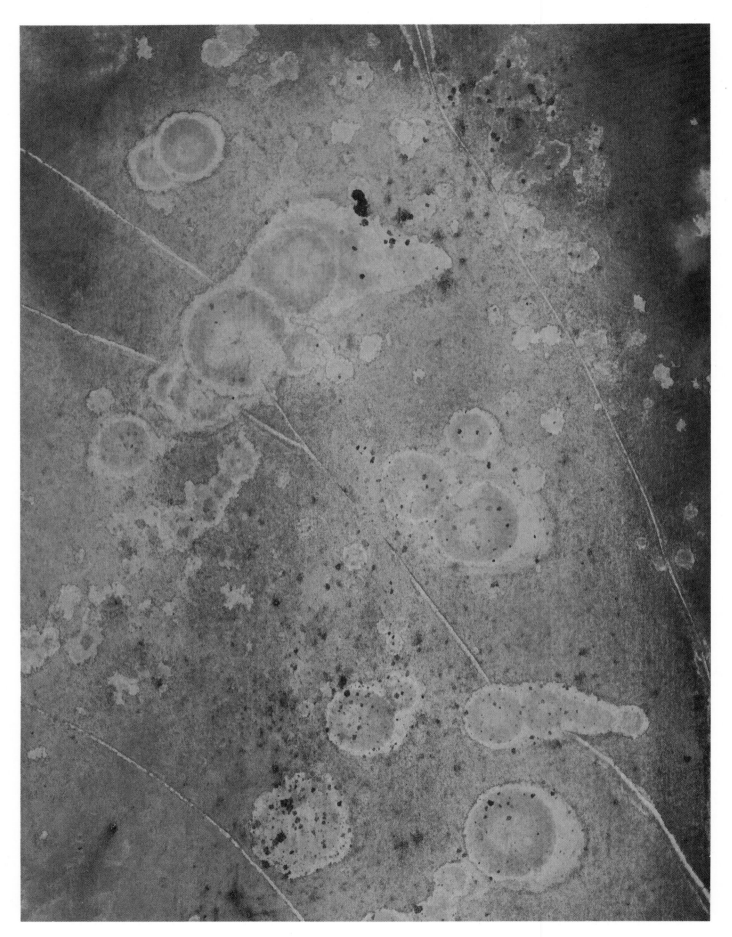

Liquid Aids

Techniques involving liquids seem an obvious place to start, since watercolor is itself a liquid medium. Moving and flowing, splashing or spattering, dripped, drizzled, or daubed, liquid aids seem to complement watercolor in a special way.

In this section we will cover the various ways to incorporate these liquid aids into your paintings, exploring their effects as we go along. Some you may already have tried; some are old standbys; others may be new to you. Keep an open mind, give them a try, and perhaps something entirely different from the ones I've offered will occur to you.

Keep in mind the permanence of your work as you play with additives. It may be *tempting* to see what ketchup (or other edibles) might do in a wash; resist that temptation! Mold, mildew, and hungry bugs might make your work nothing more than a memory!

So here are a few liquid aids to get you started. Use them judiciously, don't let them take over your work, but remember—enjoy!

Know Your Pigments

Perhaps the first order of business that will guarantee success with special effects is getting to know your pigments. Knowing what to expect of your paints will allow you to work some very subtle tricks. Learn the properties of your pigments first and foremost, and you'll be able to make use confidently of any new technique

you may want to try. Watercolor allows little room for the faint-hearted.

Learn about all your pigments; their makeup and unique properties will help you make the best possible choice for the need at hand. Even the brand you choose can make a difference; it may be best to settle on one brand and

stick to it unless you can remember which company makes what pigment form you prefer.

Take a while to become fully acquainted with each new tube you buy—and review the old ones while you're at it. If you've never played with your paints before, now is the time!

Liquitex Grumbacher
CADMIUM RED MED.

Winsor-Newton Liquitex
BURNT SIENNA

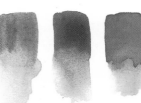
Horadam-Schmincke Winsor-Newton Liquitex
YELLOW OCHRE

Winsor-Newton Liquitex Grumbacher
RAW SIENNA

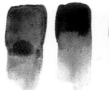
Winsor-Newton Liquitex Grumbacher
BURNT UMBER

Winsor-Newton Grumbacher
CADMIUM YEL. PALE

Winsor-Newton Grumbacher
CADMIUM YEL. MED.

Winsor-Newton Grumbacher
PAYNE'S GRAY

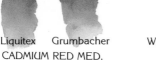

Horadam-Schmincke Winsor-Newton Liquitex Grumbacher
ULTRAMARINE BLUE

Liquitex Grumbacher
PHTHALOCYANINE BLUE

Winsor-Newton Grumbacher
COBALT BLUE

Winsor-Newton Grumbacher
HOOKER'S GREEN DARK

Brand Comparison

This gives you an idea of the variety possible from brand to brand. Make a similar chart with the paints you have on hand to familiarize yourself with their differences. I was astounded particularly by the differences between the siennas and the blues I had on hand. Such diversity is not too surprising, though, when

you consider that different companies choose different ingredients to make their colors. For example, sap green might be made of organic pigments in one brand and chlorinated copper phthalocyanine, monoazo acid yellow lake, and ferrous napthol derivatives in another.

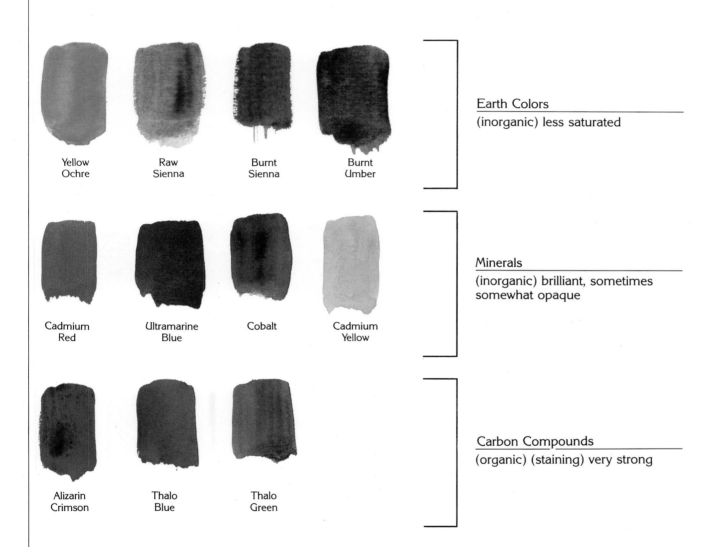

Yellow Ochre Raw Sienna Burnt Sienna Burnt Umber

Earth Colors
(inorganic) less saturated

Cadmium Red Ultramarine Blue Cobalt Cadmium Yellow

Minerals
(inorganic) brilliant, sometimes somewhat opaque

Alizarin Crimson Thalo Blue Thalo Green

Carbon Compounds
(organic) (staining) very strong

Pigment Composition

It helps to know a bit about the makeup of colors in general. When we refer to the earth colors, we mean yellow ochre, raw sienna, burnt sienna, and the umbers (as well as a few others) that are made from ground earths—mineral rich soil, clay and so on. They are inorganic and not so saturated as to pigment. The mineral colors include the cadmiums, ultramarine and cobalt blue, etc., that are also inorganic, brilliant, and rather opaque. The carbon compounds are organic and staining; use with care. They include alizarin crimson, thalo blue, thalo green, etc; they're often referred to as dye colors.

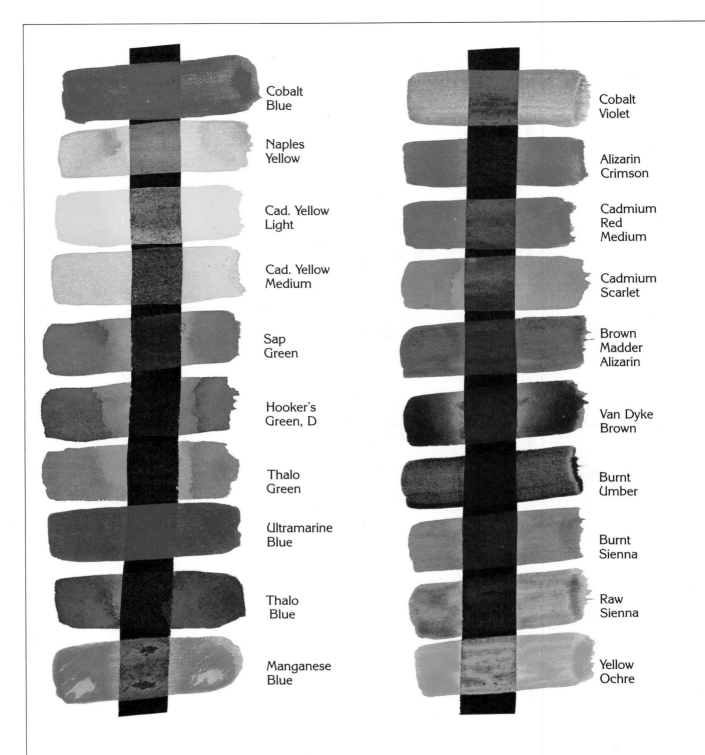

Cobalt Blue	Cobalt Violet
Naples Yellow	Alizarin Crimson
Cad. Yellow Light	Cadmium Red Medium
Cad. Yellow Medium	Cadmium Scarlet
Sap Green	Brown Madder Alizarin
Hooker's Green, D	Van Dyke Brown
Thalo Green	Burnt Umber
Ultramarine Blue	Burnt Sienna
Thalo Blue	Raw Sienna
Manganese Blue	Yellow Ochre

Color Transparency

Sometimes it is very important to know the transparency or opacity of colors; after all, when you just want to lay a transparent glaze, you'd be awfully disappointed to end up with a foggy veil instead, and when you want to cover something with a strong opaque it's frustrating to have your overglaze disappear as if it had never been. The cadmiums are quite opaque, and can be used as bright "jewels," touches of pure color, even over a very dark preliminary wash. Try the same with alizarin crimson and you wouldn't see a thing. Make a handy chart of all your colors to help you see the transparency/opacity for future use.

First, lay down a strip or two of black India ink and let it dry thoroughly. Then, simply paint a strip of each of your pigments over these black bars. Some colors will almost *cover* the black; some will seem to disappear.

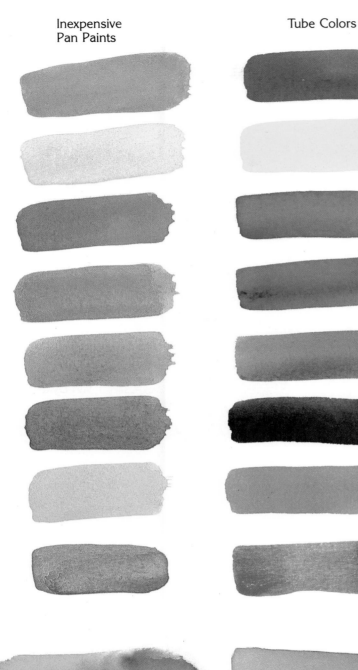

Inexpensive
Pan Paints

Tube Colors

Tube vs. Pan Colors

Remember that the *quality* of your paints is just as important as the transparency, opacity, brilliance, staining properties, or anything else, and perhaps more important. Paintings done with cheap paints may fade, flake, change color, or otherwise disappoint you. As an extreme example, I bought an inexpensive set of children's pan watercolors and gave them a fair test side by side with my tube colors. I let my mounds of color dry, then mixed each sample with the same amount of water, with the same number of mixing strokes. The difference is amazing, with comparable colors only in the lavender/purple area (and I don't care much for either!).

Triad Scheme of Secondary Colors mixed on the paper.

Same 3 colors mixed on the palette!

Palette vs. Paper

Finally, keep in mind the difference it makes when you mix your chosen pigments on the palette or on the paper; the contrast can be dramatic. If you are after a smooth, homogenized blending for flat or especially subtle effects, mix on your palette. For more exciting and varied effects, try mixing directly on your paper. (Of course, you can mix more thoroughly than I have done—this is an extreme example—but they *are* the same colors used in both rectangles.)

Pigment Tricks

It's never necessary, for instance, to buy gray in tube form—unless you just want to. (Davy's gray is rather opaque, and Payne's gray will lighten—frustratingly enough, sometimes—as it dries.) I like to mix my grays with the lovely earth colors or use a palette gray. Try it out.

The sedimenting earth colors will produce atmospheric, grainy grays, wonderful for painting the details of nature. In this sample, I've mixed my warms and cools to offer some suggestions. Try them on your own palette to see which you like best, but do mix them all. Use burnt umber with cobalt, manganese blue with burnt umber—or any other combination you can think of. Some are rich and dark, others light in value, like D, here.

By the way, A is burnt umber and ultramarine blue, B is burnt sienna with ultramarine, C is burnt sienna with manganese, and D is raw sienna and cobalt. Notice how they separate and make their own nice, grainy textures.

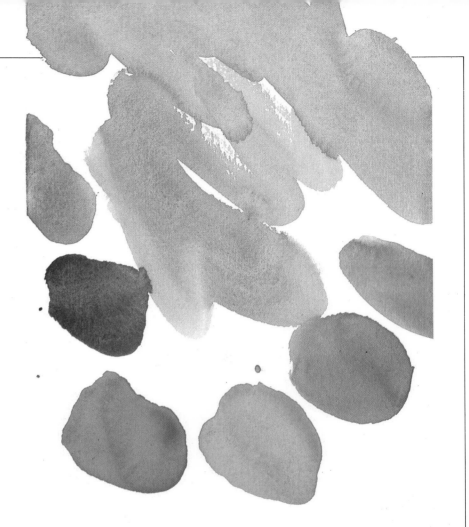

Other times, you may prefer a grainless gray; a palette gray, mixed from whatever colors are on your palette at the time, may be your best solution. These grays are very luminous—especially if you've used no earth colors—and they can be warmed or cooled according to what you draw your brush through! Here, thalo blue, ultramarine, alizarin crimson, cadmium orange, sap green, and raw sienna were variously mixed to produce the grays you see.

These lovely grays work well with people, florals, and interiors, or really any place you want a luminous, light-filled gray.

Pigment experimentation doesn't stop with the grays, of course. Try mixing the staining and sedimenting colors for exciting effects. Often, you will get a kind of halo as the heavier sedimenting color settles into the grain of your paper and the staining color spreads. Here, I've accentuated the effect by holding my paper on a slant and allowing the alizarin crimson to flow off to the side, to help you better see the effects. This could be useful in any number of watery ways, in a soft sunset, to depict a foggy morning, to suggest shadows on flesh. . . .

Pigment Discoveries

And for those among you with a color that is a pet peeve—take heart. Try mixing all of the interesting variations you can to set yourself free from your prejudice.

Mine, by the way, was green. I have often complained about painting in the summer because of all the boring, unvarying, everlasting *GREENS*. If you have the same feeling, try my solution. Mix your greens from all the blues and yellows on your palette (the browns act as yellows, as well).

Then try altering the tube greens you may have on hand with browns, blues, yellows, reds. You may find you now love your former pet peeve and look forward to ways of utilizing it whenever possible.

These greens are made the old-fashioned way—with yellows and blues. Manganese, thalo, ultramarine, and cobalt are my blues; cadmium yellow, cadmium yellow light, and cadmium orange (!) are my yellows. There are any number of others, of course. Try Indian yellow, new gamboge, yellow ochre, or any other yellow (or blue) that you normally use. The point is to get acquainted with the colors you have.

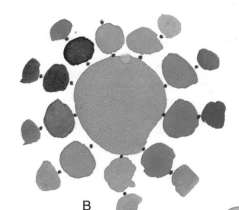

Still playing with the green theme, here I've mixed my tube greens with a number of other pigments for a fantastic variety. A is thalo yellow green, B is sap green, C is Hooker's green deep, and D, the most versatile of all, is that otherwise almost unusable thalo green. It may be too strident and acidic to use alone, but it's wonderful in mixtures.

One last green exercise. The palette of Velasquez included a green made with black acting as the blue in the primary triad (yellow ochre was the yellow, burnt sienna the red.) I've pushed this a bit further with a quartet of subtle, olive greens.

A is the normal lampblack and yellow ochre. B was made with lampblack and cadmium yellow light; C is a lampblack and cadmium yellow. Finally, the brownest of our quartet—D is lampblack and raw sienna. Any "pet peeve" color can be mixed like this; green just seems to present more universal problems—and solutions.

Clear Water

The simplest liquid aid of all is plain old H$_2$O—clear water. It's as basic to the watercolorist as pigment; if you're painting at all, it's got to be handy somewhere nearby. I try to keep two containers of water when I paint, one to clean my brush and one to mix with my pigment, this one staying relatively clean and instantly available for all kinds of special effects.

Following are a few interesting liquid aids.

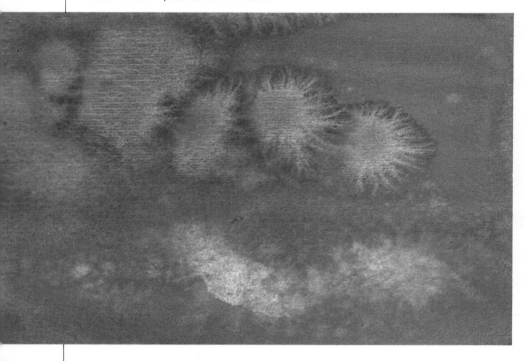

Clean water was dripped and spattered into a rich wash of ultramarine blue—the large "explosions" in the upper half are drops of water in a fairly wet wash. Notice how the pigment crawls at the edges. (When this happens by accident, we call them "flowers"—why not do it on purpose?)

The smaller droplets were spattered into the wash as it began to lose its shine. In the center, I blotted with a dry tissue. This looks a bit galactic to me—maybe it's that deep blue "sky" wash.

I've used the same ultramarine blue in a graded wash. This time I tried a more controlled approach. I lifted the lighter diagonal with a clean, wet brush and blotted thoroughly. In the center, I did the same thing without blotting, allowing the picked-up pigment to dry where it lay.

The other examples were lifted with a damp bristle brush and blotted. How many ways could you use these handy lifts? I can think of many times when I've lost an important white and needed to regain it—this is one of the first things I'd try. Keep in mind, though, that the lift won't work as well on the staining or dye colors as it does on a nonstaining pigment.

Now I've used a variegated wash of ultramarine blue and alizarin crimson. While it was still wet, I "painted" back into it with clear water on a round watercolor brush. Notice the difference of the effect on the sedimentary blue and the staining red. This is a frosty abstract effect—lots of fun.

Blotting clear-water spatters on a damp wash produces some interesting textures. Here, I've suggested a rock form with burnt umber, burnt sienna, and ultramarine blue, mixed primarily on the paper rather than on my palette. As the basic wash began to lose its shine, I spattered on clear water from a stencil brush (any stiff brush would work as well) and hit it, here and there, with a fine spray from a pump bottle of fresh water. I blotted occasionally to heighten the effect. (I also scraped in a few lines and spattered on a bit of burnt sienna for further texture.) I've used this handy trick of spattering and blotting often while painting in the field, when I'm not as likely to have liquid frisket with me. Water, I have.

India Ink

India ink has been used in conjunction with watercolor for centuries; it's hardly a new and revolutionary technique. You can use it as the Old Masters did, as an underdrawing tinted with washes of color, or in some new and different ways. It's interesting, no matter how you choose to work with it. Use it wet or dry, before painting, during, or after the fact.

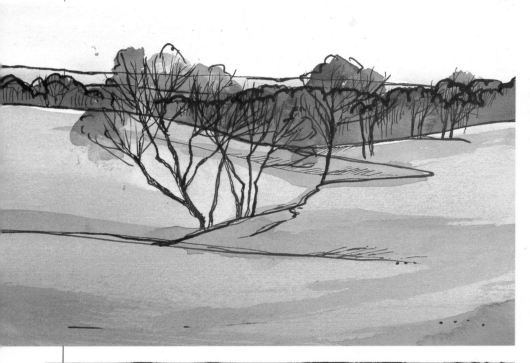

This is the "normal" ink and watercolor technique. I did the small sketch of the field with ink and a medium-nibbed pen and let it dry. Then I washed my colors in loosely with a 1/2 in. brush. Rembrandt often used this technique with wonderful results; some artists prefer to use diluted ink for their washes for a monochrome effect.

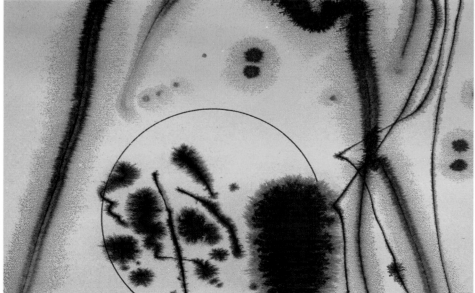

Now I'm working wet-in-wet, but what a difference from the same technique using watercolor alone! The ink blooms and spreads and goes all over the place. It can be more or less controllable, depending on how wet your preliminary wash is—and, oddly enough, on the brand or kind of ink you buy. On the far left is ordinary, stationery store India ink, applied when the paper was in various stages of wetness. In the circle, on the other hand, is Higgins Eternal Permanent Black Ink. It produces much less secondary spreading than the India ink (which was, incidentally, also Higgins.) These samples were made by dragging the ink bottle stopper over the wet wash, by drawing back into it with a pen nib, and by dropping ink off the end of my brush.

You may think this looks a bit unpredictable and unruly to use—don't let that put you off. Give it a try. I've used it to paint rugged, craggy rocks and the mixed leaf-litter on the forest floor; I've even seen a beautiful painting of an angel done entirely in this technique with a bit of opaque white added at the end to pin down the details.

Colored Inks

Don't stop with the rich blacks, however. Some artists *never* use black in their work, others really like to let "anything go." For the latter, the colored inks are made to order. If you haven't visited an art-supply store lately, do so. There are many wonderful colors available with their own very special "special effects." Sepia is my odds-on favorite. I like it for its atmospheric moodiness and its subtlety, but you may like blue, orange, or purple instead. Go to it!

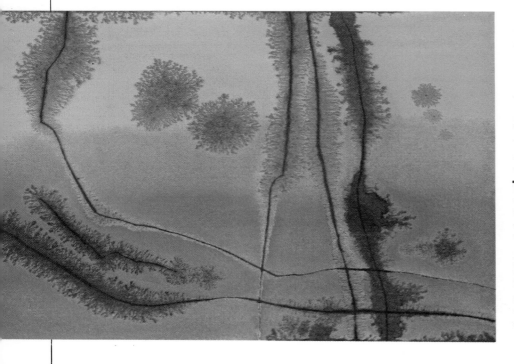

These are a few of the inks available—I've worked them into a pale thalo blue wash in much the same way as I used the India ink—very wet, semiwet, dripped, etc. You will get different effects according to what your base wash is; you may want to try a small sample sheet before painting.

Here I've explored good old sepia on two pigment types—the staining alizarin crimson and the sedimentary ultramarine. The ink seems a bit more active in the staining wash, but I was amazed to see how it actually displaced the sedimentary pigment, leaving a *lighter* line. I was very generous with the ink on the dark line at the right—it was quite juicy. You see how it seemed to spread like a centipede! The pressure of the nib made a fine line down the center of each squiggle; that effect could be avoided, if you wish, by painting it on with a brush. These two samples *look* very abstract. But the technique itself can be used in a number of ways. With it I've suggested a woodsy background, painted patterns in ice, created "flowers"—it's very versatile.

Rubbing Alcohol

Rubbing alcohol is delightfully unpredictable, like watercolor itself. Because it has a different chemical makeup from water it resists the water in your wash; at the same time it soaks into the paper more deeply than water does. Depending on how you choose to apply this liquid aid, you may produce bubbles underwater, flowers in a field, texture on an old rock, stars in an evening sky, or simply interesting textural effects. You may want to use the effects in an abstract way. Rubbing alcohol works well for many applications; practice to get the feel of it.

There is a trick to using this device: if your wash is too wet, the alcohol you drop in will look wonderful—for a second. Then it will simply fill back in, losing most of its effect. On the other hand, if your wash is too dry, the alcohol will have no effect at all.

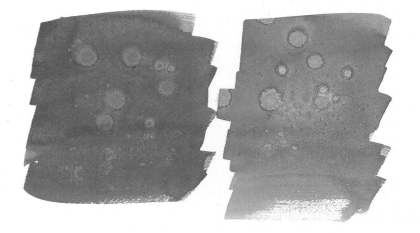

Just to find out how two blues might differ, I tried ultramarine blue and thalo blue with rubbing alcohol drips. To my surprise, I found the alcohol had a more noticeable effect on the intense dye color than on the sedimenting blue. Apparently ultramarine blue was too heavy to easily move out of the way.

Here, rubbing alcohol was dribbled into a wet wash that was just starting to lose its shine. I used a thalo blue and alizarin crimson; experiment to see what happens with your chosen colors. Mine were both dye colors, you'll notice; results may be more or less effective with sediment colors. Try it out and see.

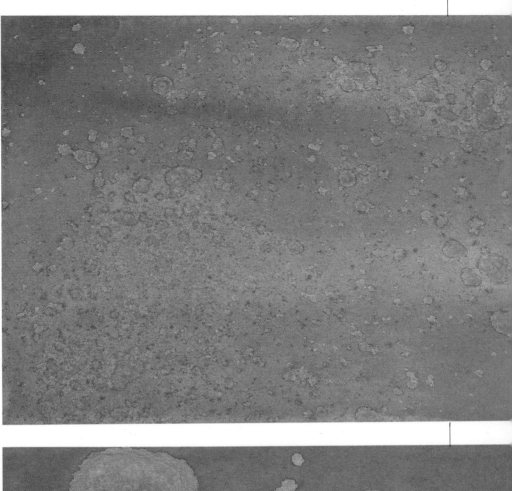

Thalo blue formed my base wash here. I began spattering rubbing alcohol from a stencil brush almost immediately, and continued at random until the wash was almost dry. I liked the variation in effects.

I'd like to see it used as a sandy shore, a weathered rock, a starry sky—it's like a Rorschach test.

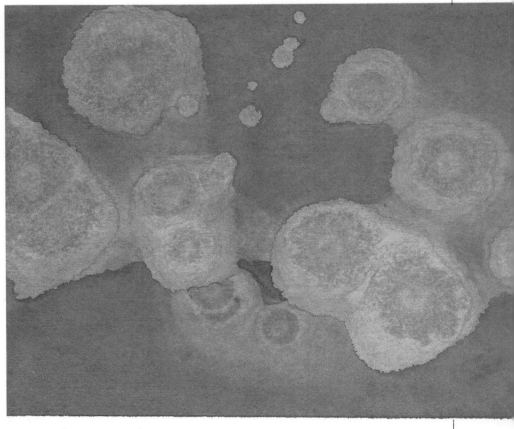

Again, I've used a dye color—sap green—as my background wash. Large drips of rubbing alcohol were allowed to fall from my brush tip in a random fashion. Look closely; here you can see the tendency of alcohol to "flower" in a wet wash, forming irregular rings. I've used it in this way to suggest flowers in a field, bubbles in deep water, city lights at night.

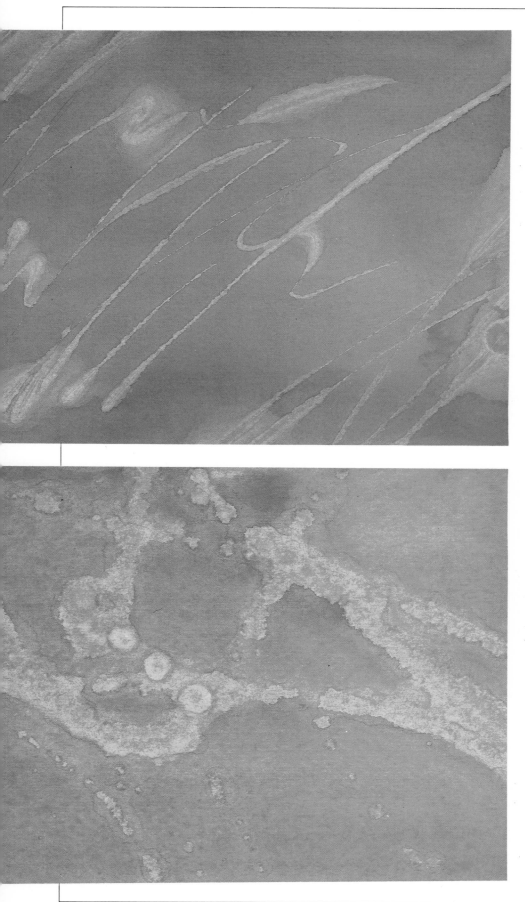

I wanted to see how rubbing alcohol would react to being applied with a bamboo pen. I like the effect, though it is quite unpredictable. At the beginning of a stroke, more alcohol spreads into the wash. I liked the frosty-weed look of the strokes, though; they spread at changes of direction, as well. I can see this used to depict frost-touched weeds, sun-struck grasses, glowing lines from cars' headlights at night, jet trails, or just interesting linear effects.

Again I've found that the results aren't quite as noticeable on a sedimentary wash (burnt sienna, the umbers, ultramarine blue, for instance), but they're still quite effective. Here, alcohol was flicked from the tip of a round watercolor brush into a burnt sienna wash. (As I have said, timing is essential; if the wash is too wet the effects blur or fill in; if too dry, the effect is zero.) I think this application suggests marble or weathered rock.

"Sunnie"
11″ × 15″ (Collection the artist)
Techniques used: liquid dye watercolor, bamboo pen, flat brush, large spatter (drips), rubbing alcohol, liquid frisket.

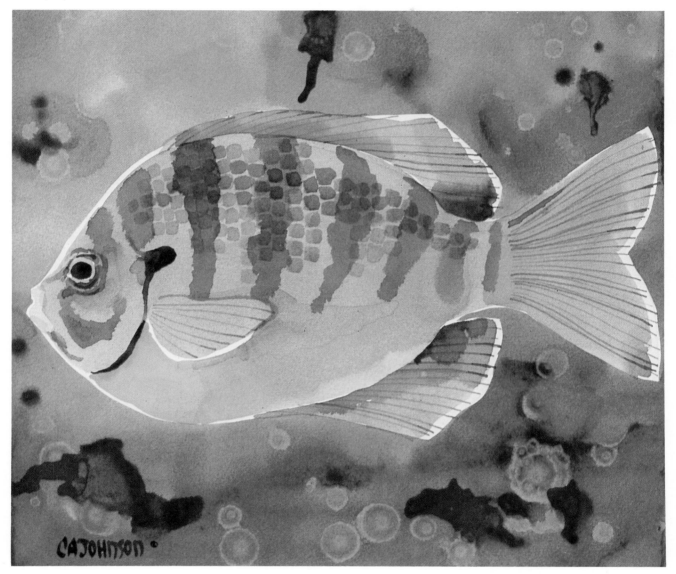

I love the bright, vivid colors of liquid dye watercolors, as well as their convenience; since they are already liquid, they need only the slightest bit of water—or none at all—to make them ready to splash on my paper. Here, I simply painted the fish form first with liquid mask, then splashed and dribbled happily with the bright watercolors in two "underwater" colors. (When I use these pigments, I am careful to buy permanent, lightfast hues. The dye colors are often used by designers and graphic artists who may only have to be concerned that the work lasts long enough to be photographed. I worry about their future a bit further down the line.)

While the first wash was still quite wet, I dropped in "bubbles" of rubbing alcohol, flicked off the end of my brush. Some of these spots are small, some large, to suggest the underwater feeling.

When my background wash was quite dry, I removed the liquid mask and painted the body of the fish, using a diluted form of the same green, plus a full-strength daffodil yellow. A small flat brush was used to suggest scales, and my bamboo pen, dipped directly into the bottle of liquid color, made the lines in the fins and tail.

Liquid Frisket

We tend to think there's only one way to use liquid frisket: according to manufacturer's directions. You know—apply with a brush moistened with soap to protect the bristles, let dry, paint over it, and remove it. And that's certainly one of the best. But why not branch out a bit with this useful aid? There are several ways to use frisket that are new and fresh and keep your work from looking too "masked out." You may think of other frisket tricks. If you do, let me know!

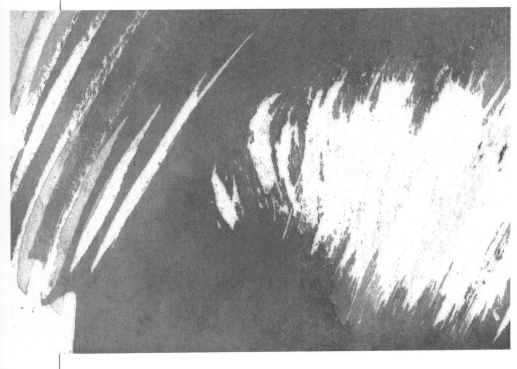

This is the traditional and expected use of liquid frisket—nothing to be underrated, at that, when you really need to preserve a white or a particularly difficult-to-paint-around shape. (Imagine trying to paint lace or a particularly detailed paisley without the use of liquid frisket. It can be done, but why not take advantage of the technology that exists? Watercolorists generally need all the help we can get.) The strokes at left were protected by using a normal round watercolor brush loaded with frisket; the grass-like patch to the right was protected with a fan brush.

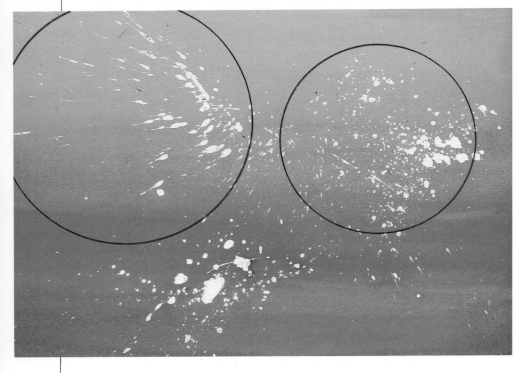

Here, frisket has been spattered on in a number of ways. In the lower circle on the right, a stencil brush has been used for small, closely spaced spatter. To the left, larger spatters were dropped off a stiff, round bristle brush, and in the circle on the left the brush was held close to the surface of the paper and at an acute angle. Makes a big difference!

Here, liquid frisket was dropped in-
to a wet alizarin crimson wash,
from the end of my brush. In the
upper left circle you can see a clus-
ter of smaller spots formed by
dropping the same amount of
frisket into the wash after it had lost
its wet shine. I've used this tech-
nique to suggest weed-seed heads
and stars in a winter sky. Allow the
wash to dry completely before try-
ing to remove the frisket. It's best to
let it dry naturally rather than use
that old standby, the hair dryer.
Sometimes the high heat generated
bonds the frisket to the paper, mak-
ing it more difficult to remove with-
out damaging your paper surface.

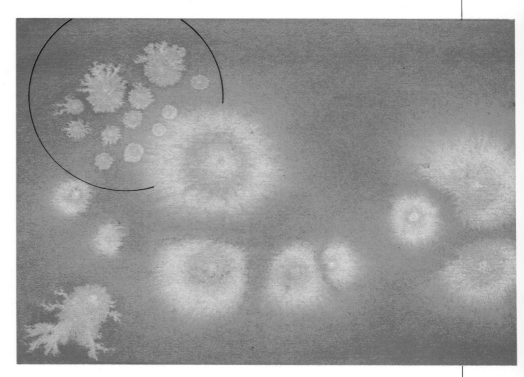

This time I used cadmium red me-
dium, to see how the frisket would
react with it. Also I spattered most
of the liquid mask into the wet
wash, making a tighter pattern. The
larger spots were dropped off my
brush as before. As you see, it's
quite different from our sample on
the dye-based wash. The effect is
less regular, less circular, but still
very interesting. This looks a bit like
red lichen, to me. (Remove the
mask with a rubber cement pickup
for best results—and be gentle. Lift
rather than scrub.)

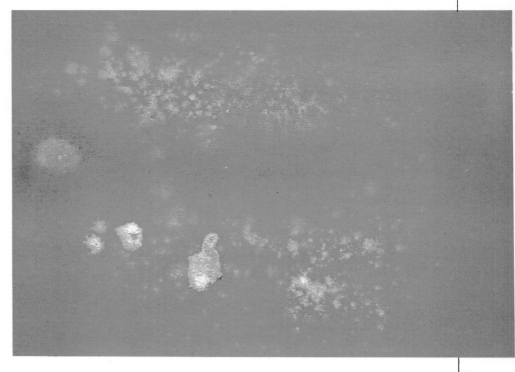

Rubber Cement

Rubber cement is very similar in use and application to liquid frisket. In fact, some artists prefer it, since it is both inexpensive and easily available. It is not water soluble, however, so it will be necessary to buy rubber cement thinner as well. You can use this volatile liquid to thin your medium and to clean your brushes afterwards, but it is still best not to use your favorite watercolor brush to apply the masking agent.

Rubber cement can block your pigments entirely A or can be used in an open, broken manner B to give a dry-brush effect. This could be useful in painting the sparkle of light on water or hair.

It is difficult to get a fine line with rubber cement unless you thin it; thinned *too* much, it will not completely protect the paper. The marks on my sample were made mostly by dropping the cement from the applicator it comes with, a freer effect than you may want.

Melted Wax

You are no doubt familiar with the art of batik; using melted wax with watercolor produces much the same effect, except that you can never completely remove the wax. This means, of course, that you can't paint over it. What you protect with the wax stays white forever since it resists water. A batiking tool called a tjantung would be very useful in making wonderful, even lines; a brush is an acceptable substitute.

Be careful when melting the wax; it is extremely flammable. It's best to use a double boiler. Remove from heat as soon as it is melted.

This watery, liquid wax feeds easily through the tjantung; simply load into the small receptacle with a spoon or other tool. If the wax is still liquid and hasn't begun to cool and thicken, it will sink into your paper's fibers with no need for later removal; if it does begin to thicken you may want to pop off the hardened wax residue before continuing.

Open strokes of melted wax were applied with a bristle brush and allowed to dry. Then I painted over them with cadmium yellow and thalo blue. I liked the way the watercolor washes beaded on the waxed areas—it adds another nuance of texture.

Now I've gone for a more controlled effect. Wax was dropped from the end of my brush and painted on in knob-ended lines. It's kind of a festive feeling, isn't it?

Opaque White

The use of opaque white with transparent watercolor is considered by some to be in a class with spitting on the flag or taking your martini stirred rather than shaken. I admit to a bit of that prejudice myself. But when I give in to it, I remind myself that what I'm trying to do is produce a painting, a work of art, not necessarily a Transparent Watercolor.

Opaque white or gouache *is* handy stuff. I have a friend who paints wonderful watercolors, and introduces opaque white here and there without the least compunction. Her work is terrific; the white isn't noticeable as an addition after the fact. Nor does it look "pasted on," a common complaint of the pure aquarelle crowd. Philip Jamison uses it well; so does Maxine Masterfield. This is like any other prejudice—it needs to be overcome.

Here, then, are a few suggestions for using this handy liquid aid.

The handiest—and least noticeable—use of opaque is in spatter. Here I've suggested a field of wildflowers by spattering judiciously with white, pink, and yellow. The new colors can be obtained by mixing white with your palette watercolors, if you don't want to invest in tubes of gouache pigments. They are rather expensive, and until you know for sure you want them, stick with a tube of white or use a product like ProWhite, often used by graphic designers to correct mistakes on pen and ink drawings.

This is the spattering technique, as I most often use it. There's no better way to suggest falling snow than with a bit of opaque spatter when your painting is all finished. To apply, thin the opaque white to the consistency of light cream but not so thin that it is no longer opaque. Spatter on from a stiff bristle brush; I use a stencil brush, a fan brush, or an old toothbrush. Try to vary the size of the droplets for interest and keep them somewhat clumped to give the feeling of snow flurries.

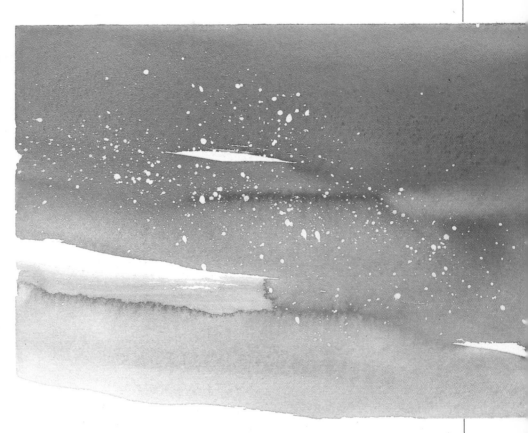

Spatter again—this time as a starry night sky. The only difference here is that I tried to keep my spattering more uniform to suggest a star-filled sky. Then I went back and created a "galaxy" or two here and there. (A big job. It wore me out.)

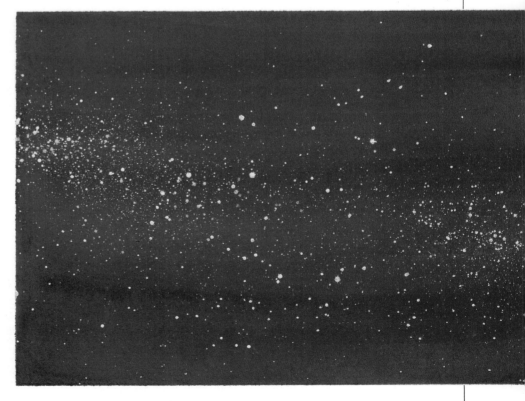

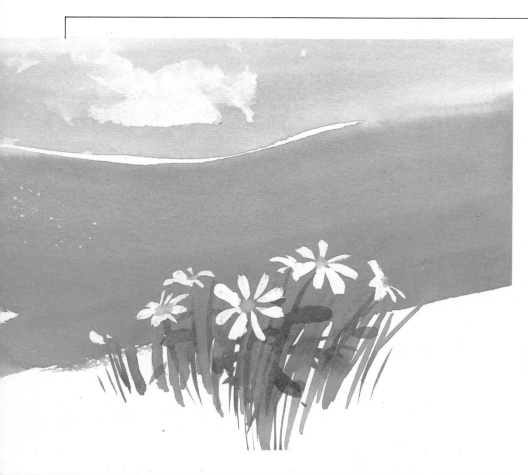

Don't think opaque white is useful only for spatter. The Old Masters sometimes mixed it with each color on their palette for a soft, moody effect. Here I've made a clump of daisies against a hill. Everything was painted and allowed to dry thoroughly—sky, hill, stems, and all. Then I used opaque white straight from the jar for the petals, remembering to let the flowers face naturally in several directions. When the ray petals were almost dry, I added the disc florets by mixing a bit of cadmium yellow (already a rather opaque pigment, as are all the cadmiums) with a little white. You could use this same technique to paint sails on the water or perhaps windows in a building.

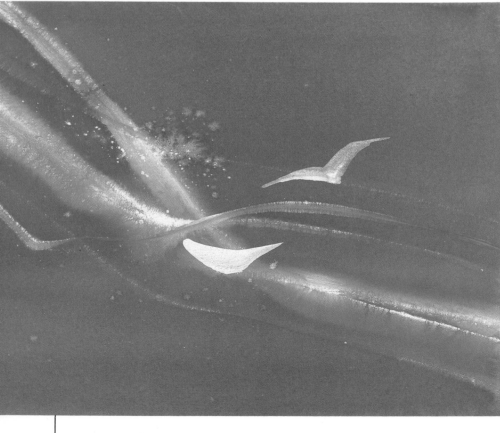

White reacts interestingly with water; try it in a wet wash. I like the soft "vapor trails" here. Notice I've used a bit of wet-in-wet spatter; it reminds me of altocumulus clouds, high and patchy.

This time I've used opaque white in a squeeze bottle applicator for interesting linear effects. You might use this in an abstract way or to suggest light on incoming waves, kite strings, clotheslines, or whatever your imagination dictates.

Here I've contrasted white *ink* with ProWhite, the liquid watercolor retouching paint. Everything in my sample is white ink into wet wash and on dry paper, except the bottom two lines A, which are paint. The paint seems to be a bit more opaque; it certainly fed more smoothly from the pen nib I was using. It needs only to be thinned a little before charging your pen nib.

Opaque white also makes a veil of varying transparency, depending on how much water you mix in. Look at B; I thinned my mixture by about half, then spattered the lower edge with clear water.

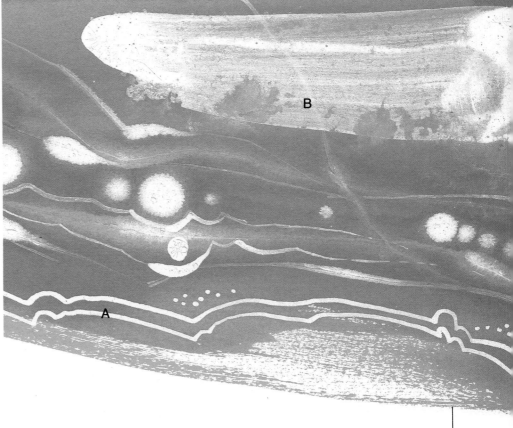

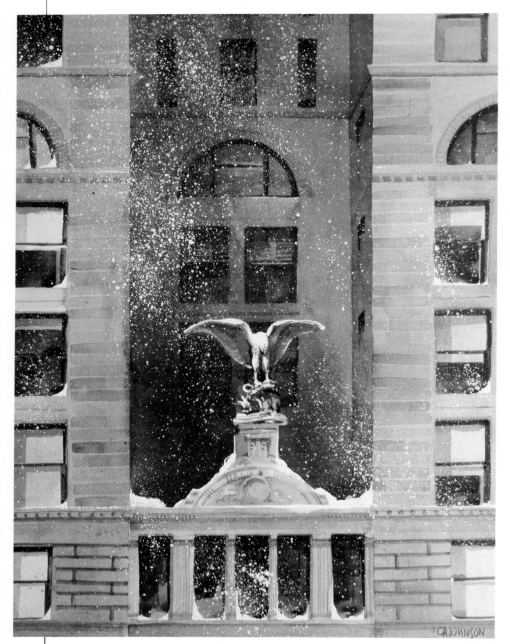

"Winter Eagle"
15″ × 22″ (Collection D. W. New-
comer and Sons, Inc.)

I protected the shape of the eagle and his pedestal with liquid frisket before beginning to paint. The snow built up in the corners of the windows was protected the same way, and when the mask was dry, I painted the building with a varied wash of burnt sienna and ultramarine blue. A flat brush was handy to suggest architectural details of the large blocks in the building's siding.

When the painting was almost complete, I spattered in the "snow" with opaque white gouache, mixing it fairly thickly and flicking it off a stencil brush with my thumb. This allowed me to have some control over the direction of the spatters so it looked like blowing snow.

Turpentine

You've heard that oil and water don't mix; nowhere is it more true than in watercolor painting. You can put that truism to work in your paintings, though, for atmospheric or abstract effects that can be gained in virtually no other way.

This is the result of first mixing a puddle of watercolor, then dipping my brush in turpentine. It starts out watery, like a normal wet-in-wet wash, then becomes nicely textured and scratchy at the end of the stroke.

Here I've first wet my paper with a clean brush and turps, then painted over it with watercolor. The effect is wonderfully streaked and bubbled; it would be good for somewhat abstract background effects.

Glue

You may never have used glue with watercolor—and sure enough, you don't mix it with your paints unless you want to destroy your brush. You can, however, use it in various ways to create interesting linear effects. The demonstration below shows how.

Apply liquid Elmer's-type white glue or school glue in linear strokes or dots directly from the squeeze bottle, or paint it on with an old—and disposable!—brush. Allow it to dry completely; set it aside overnight, if possible. Then run your washes over the raised lines you'll find on your paper. The paint will puddle somewhat beside the glue lines; that's part of the effect.

Unlike liquid frisket or rubber cement, though, these lines are not removed after your washes are dry. They are a permanent part of your composition—to remove them would be to destroy your paper. This technique may not be suitable to enter in a show requiring pure aquarelle—it's definitely "mixed media."

Soap

A bar of soap is useful for more than cleaning up after a painting session; and for more than protecting your bristles before dipping them into liquid frisket, as well. It has also been used to give definition to your strokes, that is, to keep them distinct and separate. Designers sometimes mix a bit of soap into their paint when they don't want it to crawl on a questionable surface—a slick one or one that might have been tainted with the oil from their hands. Only a very little bit is used in that case.

This is not the place for scented, colored, or deodorant soaps; the purer the better. I use a cake of plain, white Ivory soap in my studio—the same one I keep on hand for that liquid mask.

In my sample, soap lends a bit of body to the pigment, almost like working with a slight impasto. You can see each overlapping brush stroke, even though they were all painted at one time. Normally, the strokes would run into each other and all have the same general hue. Here, there is a sense of depth as the later strokes seem to come forward. I varied my color mixes a bit to make it easier for you to see the effect. You can also see the bubbles at the bottoms of the strokes—it's best to avoid that if you can, unless you just want the extra texture. Mix gently or allow the soap mix to stand until the bubbles burst.

This technique can be useful in painting a grassy field (each stroke suggests a blade or clump of grass), weathered wood, rusty textures, hair—anything where you want your individual strokes to stand out. It's somewhat the same final effect as painting on hot press paper (see the section on Dry Helpers) but more controlled.

Now I've tried to suggest a rusty texture with my soapy brush—the effect varies with direction of brush strokes, degree of manipulation (I textured it with the side of my hand) and the pigment color you choose.

Winsor & Newton Aquapasto

Soap is a very old way of giving your brushstrokes body; here's a brand new one, from the makers of my favorite tube colors. It too comes in a tube; it's a tan gel, about the consistency of thick toothpaste. Aquapasto is thinned with water and mixed with tube watercolors to produce as thin or thick an impasto effect as your heart desires.

Here we see the individual nature of brushstrokes with the impasto medium added. I was fooling around with it, fingerpainting into the damp "wash" (it really can't be called that, with this stuff) and then marking with my finger. This of course led to further speculation and lots of green thumbprints, some of which sprouted trunks and became miniature trees.

The paint seemed to lose a little of its brilliance with the mixture, but you still might like it for depicting textures.

Gel Medium

You may be more familiar with the old acrylic painting standby, gel medium. It can be used in the same way as soap and Aquapasto, with the advantage of being transparent when dry. It is easily available nationwide. The disadvantage of this medium is that it, like all acrylic products, is hard on your brushes and must be washed out immediately after working.

The light green shows normal brushstrokes—nice and distinct, thanks to a gel medium. Above I've used a fan brush to accentuate the grassy feel my first strokes put me in mind of. Short, choppy, upward strokes were used below, still with the fan brush. In each sample, my paint was thinned with gel medium instead of water.

Now, I've built up various textures using the gel medium and allowed it to dry before overpainting. (Perhaps I don't use this technique often because it requires too much waiting time; overnight is best.) The gel medium resists the wash slightly, like gloss medium.

Gesso

Gesso is another tool we may borrow from the acrylic painter's repertoire. It makes an interesting texture if used in a loose, scumbling manner; a more linear texture is applied with parallel brushstrokes. Of course, if you prefer to avoid the obvious textures, you may sand the gesso when dry with fine sandpaper or emery paper. Two or more coats will produce an extremely hard, fine surface.

The point of all of this is to make your paper surface impermeable; your washes sit on top and make interesting textures of their own. They bubble and flow in unexpected ways that can give your work a fresh look.

Here I've begun each stroke on cold press watercolor paper and finished it on gesso-coated paper. You can see the difference in how the surface accepts the washes. From the top are alizarin crimson, thalo blue, ultramarine blue, burnt umber, and burnt sienna.

Now I've branched out into a more practical application. Sedimenting colors were used to encourage puddling and settling into the scumbled surface of the gesso. It looks like a lovely, light-struck brick wall to me, so I've suggested a bit of brick texture.

Gesso was used to build up textures, using the side of a flat watercolor brush and a rubber cement pickup. When it was thoroughly dried, watercolor washes were dashed lightly across the top and allowed to settle into the textures.

This is a gesso collage; a layer of gesso was painted onto my watercolor paper, then paper towels, tissues, crumpled waxed paper, wood chips, and cornmeal were attached to the surface with more gesso. (Yes, I know I warned you against using edibles in your tricks; the cornmeal is enclosed in a layer of acrylic gesso. Paintings I did using this technique fifteen years ago are still untouched by insect damage, so I felt safe in recommending it.) When the gesso was completely dried (overnight) I added loose watercolor washes.

Gloss Polymer Medium

Gloss medium gives much the same effect as turpentine, without the smell. It resists watercolor washes if they are quick and light; if darker or more forceful (applied vigorously) they overcome the resist and a bit of polymer texture shows through. It can be a handy trick.

Here alizarin crimson and ultramarine blue are again contrasted for their staining and sedimenting qualities. A is a light wash of ultramarine (I think a bit of alizarin sneaked in). B and C show alizarin painted lightly and quickly and then thicker and with a degree of force over a layer of dried medium. D is a strong, overwhelming wash of the ultramarine.

This time I scumbled on the gloss medium; you can see the subtle texture as it shows through the overwashes.

Cooking Spray

Try vegetable-based cooking spray as a resist method. It is very subtle; more so than frisket or rubber cement, much more so than wax.

First I sprayed my paper with a shot of cooking spray and allowed it to dry. Then a wash of sap green was drawn over the resist area. It's a nice speckled effect.

This time I painted a blue under-wash before spraying. The second, green wash speckles to show spots of blue. This could be useful to show rock texture, organic effects, whatever it might suggest.

Ox Gall

This is an old additive intended to be used to give washes a freer flowing quality; it is a wetting agent. However, I like to use it to give unexpected textures to wet washes. It is similar in effect to painting back into your washes with clear water, but the effect is softer and a bit more controllable. Drop it from the handle of your brush, apply it with a pen nib, or paint it into a wash that is just beginning to lose its wet shine.

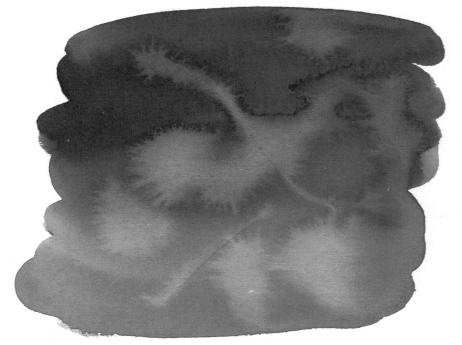

This is the effect of ox gall on a staining color, thalo blue. I found it very interesting and organic.

Ultramarine blue is the base wash for this application. It seemed to spread more quickly than the dye color. Notice how the ox gall pushed the pigment aside in the lighter areas.

Again, a nice texture for rocks and boulders. Burnt sienna and ultramarine blue were my base wash; ox gall was applied with a brush and a pen nib.

On sap green, the spots of ox gall look a bit like reindeer moss or frosty flowers. Some larger spots were dropped from the end of my brush; smaller spots were spattered on with a stencil brush.

48

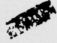

Dry Helpers

There are a number of nonliquid aids that can help add life, color, texture, and an individual stamp to your work. The dry helpers include drafting and masking tape, salt, tissues and paper towels, plus several less well-known helps: aluminum foil, waxed paper, plastic wrap, and more.

These aids, happily, are less likely to cause problems than some of the liquids. We won't have to worry about permanence—at least not as much as with the liquids. These helpers are for the most part readily available. Your own kitchen may supply you with many of these handy media; a trip to the hardware store or pharmacist may round out your collection of "art supplies." But the granddaddy of all dry helpers for the watercolorist is the very ground we work on: our paper.

Paper

Watercolor paper is alive; it's beautiful and varied and, sometimes, as unpredictable as the medium itself. You will want to try many different papers till you find one that suits most of your needs. Consider all the possibilities: rough, cold press or hot press; hand made or mold made; French, Italian, English, American; 100% rag, mulberry or rice paper, or even fiberglass (yes, Strathmore's Aquarius).

You may like the 300-lb.-or-heavier papers, if you work very wet. I use 140-lb. for most applications; you can even get 70-lb. paper if you plan on stretching your paper before working.

I use Fabriano 140-lb. cold press for most things; a good hot press paper or board when I want those special effects, and Crescent's cold press watercolor board for other projects or things that may get rough handling.

Take a look at our samples, but don't stop there. This is one place that needs hands-on experience.

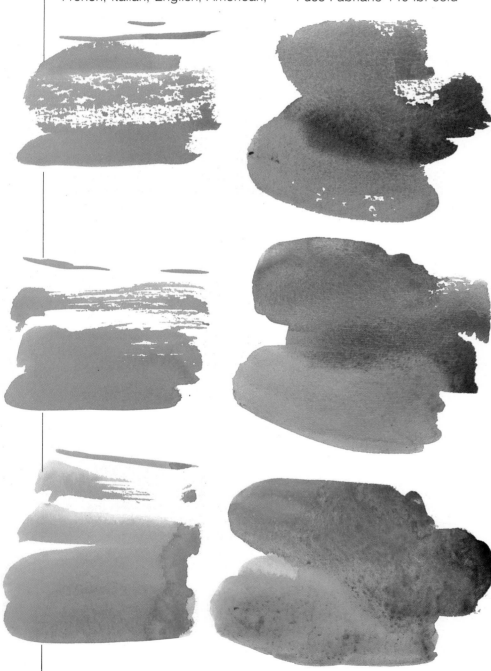

Our samples show the differences in the three basic paper types: rough (top), cold press (center), and hot press (bottom). Notice the blue strokes; here, I've made one or two straight strokes with the body of my brush, one dry-brush stroke, and one with the tip for each kind of paper. You can see how much more open the strokes are on rough paper; the pigment hits the "peaks" of the paper without going down into the "valleys." The strokes are also smoother when wet on the rough paper; strokes tend to flatten out on this paper.

On the right, I've mixed colors on each paper to show you how each takes varying pigments. A smoother blending is possible on rough paper, again because the pigment evens out in all the miniature valleys. For my money, it's smooth *enough* on cold press, and just plain *fun* on the hot press. I like the way the colors kind of pull away from the edge and puddle where they meet.

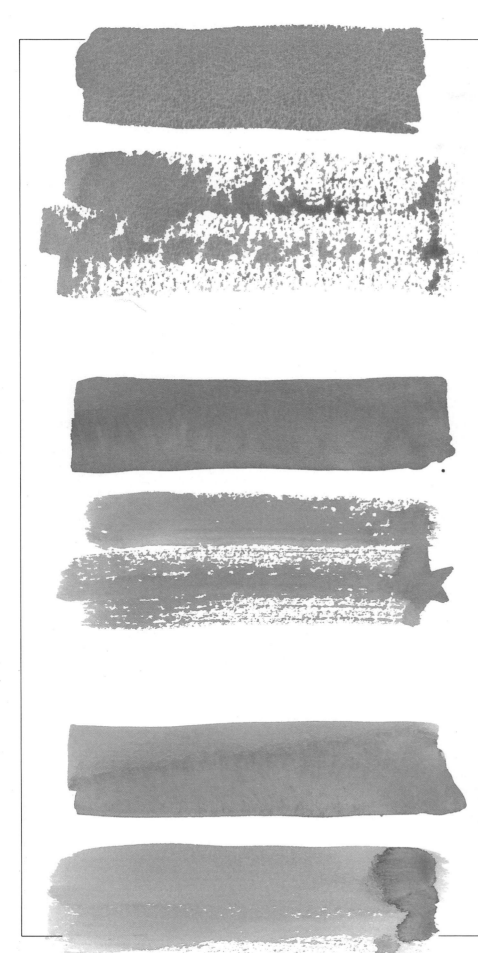

How you hold your brush affects the way the pigment goes on with each different kind of paper. In this sample, done on rough paper, above is shown the effect of a flat brush held perpendicular to the paper's surface. Below is shown what happens when the brush is held flat to the paper and a rapid stroke is made with the body of the brush rather than the tips of the bristles. It is very open and sparkling where the dry-brush type of stroke was used.

This is the cold press paper. The samples were made holding the brush vertically and almost horizontally (below). You still get the benefit of a bit of texture in the openness of the strokes, but with a little more control and conscious decision making than is possible with the rough paper.

On the hot press paper, the strokes are nearly alike because there are no hills and valleys to affect the openness of the stroke. In order to get any dry-brush effect at all, it was necessary to literally dry my brush on a piece of tissue.

As mentioned, it is easy to pull a flat wash on rough paper; almost its only advantage, to my way of looking at it! Here, the bead of paint was drawn down the paper where it settled smoothly into the texture.

The lavender wash on cold press is very nearly as smooth as on rough, with only a slight variation that seems to add a bit of interest, to me.

On hot press paper, the "flat wash" isn't. I like the streaks and flowers and backruns. If you prefer more control, you may not like this paper.

Some papers take more readily to wet-in-wet techniques than do others. Here rough and cold press papers excel. Hot press is a bit more difficult to handle. This example is wet-in-wet on rough paper; notice the smooth blending and rather soft feel.

Cold press paper, once again, takes wet-in-wet smoothly enough for my taste. The pigments still blend softly, though with a bit of puddling, as you can see, in the blue area.

Wet-in-wet is difficult to handle on hot press paper, but it can be done. Here, I allowed the washes to dry naturally, with no attempt to pick up the excess moisture that caused the big backrun. If I had been watching, I could have lifted that "flower" with a damp tissue and at least partially avoided unwanted texture. It *is* tricky, as you see.

Oriental Papers

The beautiful Oriental papers are as varied as you can imagine, depending on their basic ingredients as well as any additives. You may prefer rice paper for its absorbent whiteness, or you may prefer mulberry paper. Some kinds are nearly as stiff as regular watercolor paper; others are thin and delicate and come in long scrolls, allowing you to cut whatever size you need. One interesting paper has bits of dead leaves as a texturing additive—might be fun to work around.

One of the Oriental papers I find challenging has a design molded into the surface during the papermaking stage. If I can work around the patterned surface in an effective way, my painting is more exciting than it would otherwise have been.

This is rice paper, available at virtually any art supply store and by mail from any of the larger art suppliers. It's extremely absorbent; each stroke sinks right in. You can get nice soft effects with this paper that are unobtainable any other way.

Now, I've crumpled my rice paper and sprayed it with clear water for a wet-in-wet effect. I liked the way the creases in the paper (not visible here) suggest texture.

Some of the Oriental papers come with interesting textures built right in. This one is a mulberry paper, with threads of plant material incorporated into the body of the paper. Work with this texture or work around it for unusual effects.

NOTE: Since some of these papers are so absorbent, your strokes will look darker as you lay them down. As the paper dries, however, they will lighten. Learn to compensate for this oddity by being bolder in the strength of your washes.

Colored Papers

Colored papers give a whole new dimension to watercolor. The color you choose to work on adds a halftone aspect to your work as well as affecting the overall mood of the piece. Values are changed somewhat; unless you employ opaque pigments, your lightest value will be the value of the paper itself.

The colors can be very effective in expressing time of day, ambience, temperature, or any number of other factors. I often use scraps of colored matboard to sketch on; finer papers are available for more permanent works. Consider papers intended for use with pastels or printing; just be sure they have a neutral pH if you plan to use them for a lasting work.

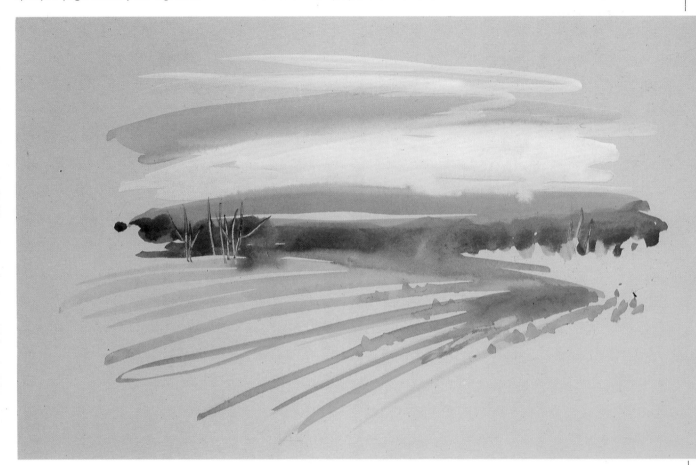

Here I've used transparent watercolor mixed with a bit of opaque white to give me a wider value range. The spring green of my paper provides a ground from which to work with only a suggestion of the other colors. You "see" the fresh young growth without my painting it, because of the paper's color. You can use this to good effect, depending on the color you choose as a ground; I've used a medium blue to suggest a cold winter sunrise, a warm sienna to suggest a fall day, a daffodil yellow for a summery feel, red to suggest excitement—the possibilities are endless.

Scratchboard

Scratchboard is a clay-coated paper used mostly by illustrators to produce sharp black and white drawings. Since it is very slick, washes cannot be painted on smoothly. It's a bit like using hot press paper, only more so; the clay coating is also somewhat absorbent. Still you can get interesting results if you experiment.

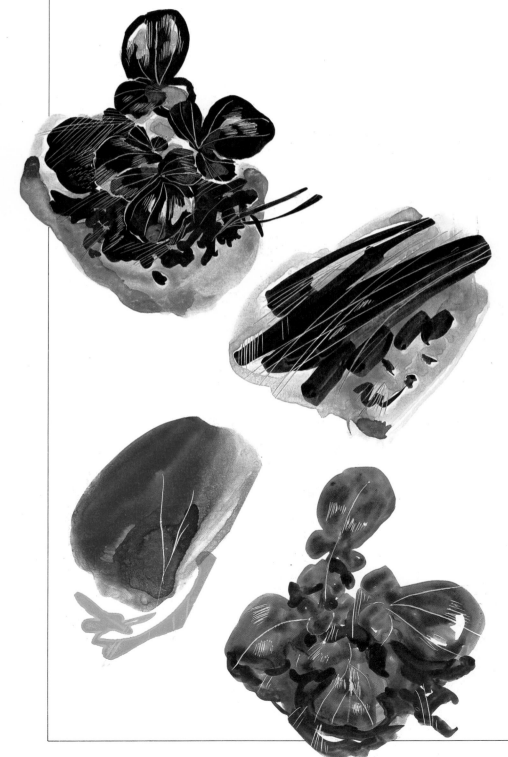

India ink is commonly used to paint or draw a design on scratchboard as I did here. After it is thoroughly dried, you scratch through the ink's surface to the white below to add details or texture. (You can buy an already inked sheet that comes completely blacked if you plan on only a little white line work.)

Here, I've added watercolor washes, once the design was scratched. If you use the heavier earth pigments or the cadmiums, some of your color will remain on top of the ink and affect its value and purity; if you use dye colors, instead, the ink will stay pure black and the color will seem to have been applied only to the white areas. Some artists use an airbrush loaded with transparent watercolor to get a smoother effect when tinting these drawings, but I prefer the looser, washier effects of paint applied with a brush.

You may want to experiment with watercolor pigments alone on the scratchboard surface and not use India ink at all. Or try your ink in diluted washes. Just be sure and let whatever you use dry *thoroughly* before scratching back into it (several hours is best).

You'll get better results with this technique if you stick to nonstaining pigments; the dye colors sink into the clay coating and stain it far below the surface—you lose the effect of the scraped white lines, as in the orange area.

Salt

Salt has become quite ubiquitous in the watercolorist's toolbox. It's in danger of being overused by its very usefulness in creating texture. Try it sparingly and only where it counts! It can suggest starry skies, flowers in a field, sandy ground, or simply an interesting texture—but again, don't get too dependent on it. Like many tricks, if it is too obvious it becomes jarring.

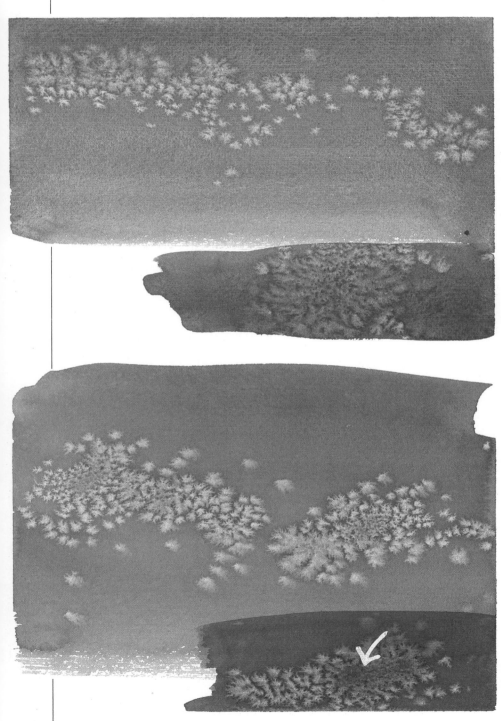

Salt has more or less effect, depending on the type of pigment you choose. Here, ultramarine blue was chosen in two varying strengths. With the heavier, sedimenting pigment, the effect is not so great.

Salt works in watercolor because it repels the pigment while attracting moisture—it pushes the color away from itself, creating lighter spots in your wash. If you apply it too early, when your wash is still very wet, the effect is largely lost—if too late, when your wash is almost dry, the effect is again lost. Watch to see that your wash has begun to lose its shine, then sprinkle in salt grains here and there. I drop them from a shaker or from a small handful, pinching a few grains between my thumb and forefinger for extra control. This allows me to place exactly as many salt grains as I need (no, I don't *count* them!) without overdoing, and puts them just where I want them.

Thalo blue, a staining or dye color, is more affected by the salt in the wash. The lights are almost pure white paper, and the effect is still quite visible on the darker wash in lower right. The arrow marks the spot where I got too much salt in a tight concentration; it was unable to work its magic.

Try different kinds of papers for new effects. This is a hot press paper; the thalo blue wash flowed and spread interestingly with salt while the burnt umber just kind of sat there. This is a heavy, sedimenting color, not as much affected by salt on any paper surface, of course.

Try different kinds of salt for varied effects; you might like the fine grain of popcorn salt or the variable sizes of Margarita or kosher salt. I have the best luck with plain old table salt; the wetness of the wash seems to control the size of the light "flower." I tried rock salt, that large-grained, coarse salt used on icy sidewalks and to make homemade ice cream, but it was so large and flat-sided it simply sat on my paper. My pigment made dark stains under the huge pieces and refused to dry for hours.

Salt *does* affect the drying time of your paper; it will take longer because the salt attracts the moisture in the air as well (in fact, years later these areas may still be attracting humidity.)

Common mistakes with salt are to apply it in too widely spaced and overall a pattern, or too clumped up in one spot in a little mound.

Once your wash is completely dry, brush the salt away gently to leave the lovely effects on your paper.

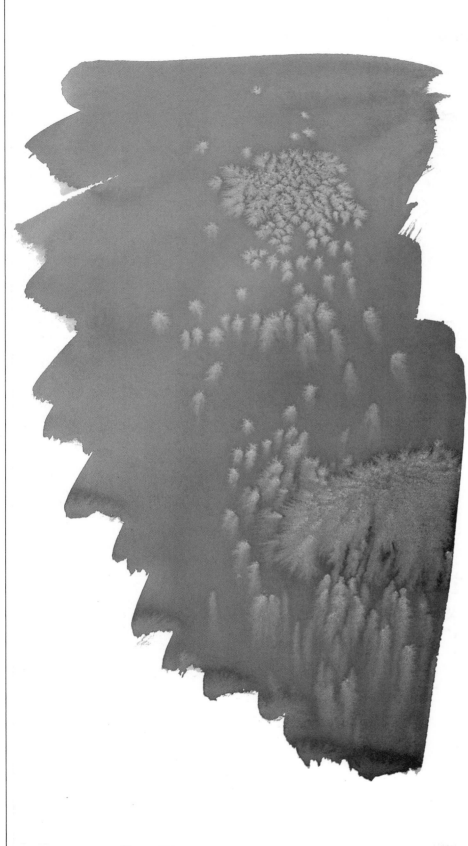

Tilt your paper to make the salt flow with gravity. This is a mixture of alizarin crimson and thalo blue pigments; I tipped the board at an acute angle, making the bluer area stay wet longer. Notice how the salt traveled in this area. I'd like these frosty effects on an icy puddle, a winter window pane, a snowbank.

Other Additives

Use sand as a sprinkle, like salt. Instead of the white flowers salt will form, however, sand and other granular additives make a darker texture. I use it in the obvious place (texturing sand) as well as in many other applications.

In addition to sand, consider other texturing agents that can be sprinkled. You could even use dirt! Gravel of varying sizes would be interesting; or try pebbles.

Beads of various shapes and sizes make nice additions—just remember to remove them all when dry.

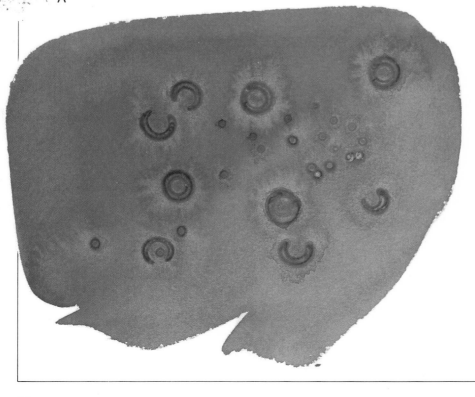

A

Sand was sprinkled into a wet wash and allowed to dry thoroughly in place before brushing it away. I could also have used the pigment-damp sand to paint with, as at A.

I've used two sizes of beads in a wet wash; tiny glass beads and large, hand-made ones. To make sure they made a splashy effect, I dotted them again with pigment after I dropped them into the wash. This built up a small dam of color around each one that dried with a sharp demarcation line. The effect would have been much more subtle if I had only let them dry as is.

Plastic Wrap

Plastic wrap is in some danger of becoming the salt of the eighties. It can be overused and obvious; try to integrate it into your painting, or use it in a way that makes sense. Maxine Masterfield uses it well in her book, *Painting the Spirit of Nature* (Watson-Guptill Publications, N.Y., 1984). She com-bines it with other techniques in a non-representational way. I use it in less abstract ways, since that is how I have evolved as a painter.

To use this enticing tool, lay on a wet wash, as strong as you like. (Masterfield uses inks—you may like the effect of liquid dye watercolors. I simply use a strong wash of whatever's on my palette.) While it's still wet, lay on a sheet of plastic wrap, crumpled or not. Let it dry in place, if you wish (this will take a day or two) or remove it after only a few moments for softer effects.

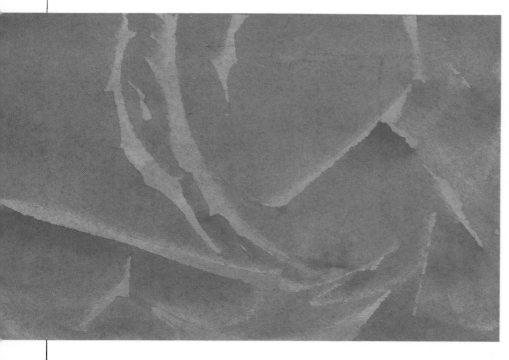

I've used Saran Wrap in the simplest, most straightforward way to get this effect. First, I laid down a wash of alizarin crimson and thalo blue and allowed it to *begin* to lose its shine. Then I put a sheet of plastic wrap over the whole, keeping it relatively smooth, and lifted it almost immediately. What does it remind you of? Marble floors? Northern Lights? Cracks in a lime-stone bluff? Weeds and sticks on the forest floor? Alter your colors and use it as you like; it will be different each time.

Any plastic wrap will do. I like Saran Wrap for its ability to take punishment and reuse. It springs back.

Here I've used a similar technique on an alizarin crimson wash, but I crumpled the wrap first, then lifted it, repositioned and lifted again. I textured a bit in the lower section by stamping into the wet wash with the crumpled plastic wrap—interesting effect, isn't it? I see this as frost on the window—or on a creek; a rocky hill; a moonscape; hardening lava.

Now, I've tried the same effect in two different ways. The top sample is on a puddle of an off-brand of rather turquoise thalo blue. It was allowed to stay in place a bit longer—about ten minutes. Notice the edges are harder and more definite.

The sample below shows the effects of a double wash. First, al-izarin crimson was puddled on and textured with the wrap. When that was dried, a second wash of cobalt blue was floated over the first, making sure not to lift too much of my initial crinkled wash. It, too, was textured with Saran Wrap. I like this effect a lot—it's transparent and has a kind of depth that could be useful.

In this sample I've left the Saran Wrap in place to dry completely on an alizarin crimson and ultramarine blue wash; I like the hard edges and the way the blue has almost outlined the light rose lines. I can see this used in a number of ways.

I've tried the same thing with "boulders" of burnt sienna, ultramarine blue, and sepia umber. I like the ancient, textured surface it suggests. A bit of veining along the cracks, or spatter to give the feeling of pitting, would make these quite believable without the temptation of overworking them.

I decided to try Saran Wrap as an actual painting tool rather than something affecting the pigment after it was applied, so I stamped the rock here and there with crumpled plastic wrap dipped in warm and cool darks. I was pleased enough with the results to add cracks and shadows. I can see that this would be useful to paint rough earth, a sandy shoreline, short grasses, or any number of textures.

Here I've painted a strong wash of thalo blue, and while it was still quite wet, laid plastic wrap on top, arranging some vertical folds. Then, while it was still wet, I pulled the plastic wrap away, leaving interestingly varied, soft lines. This really does remind me of the Northern Lights—or perhaps the edge of Morning Glory Pool in Yellowstone Park. It looks a bit like a fountain, too; perhaps if I had used a different background color all my images wouldn't have been so watery!

I used this technique on a painting in my previous book, *Painting Nature's Details in Watercolor,* to suggest a pool of frozen ice. It's quite a handy trick.

On the opposite page is a detail of a painting in which I used crumpled plastic wrap to texture the lintel. It was applied while the paint was still wet and removed before it dried. When I took the plastic off, the pigment was still damp enough to allow a bit of scraping to suggest a crack.

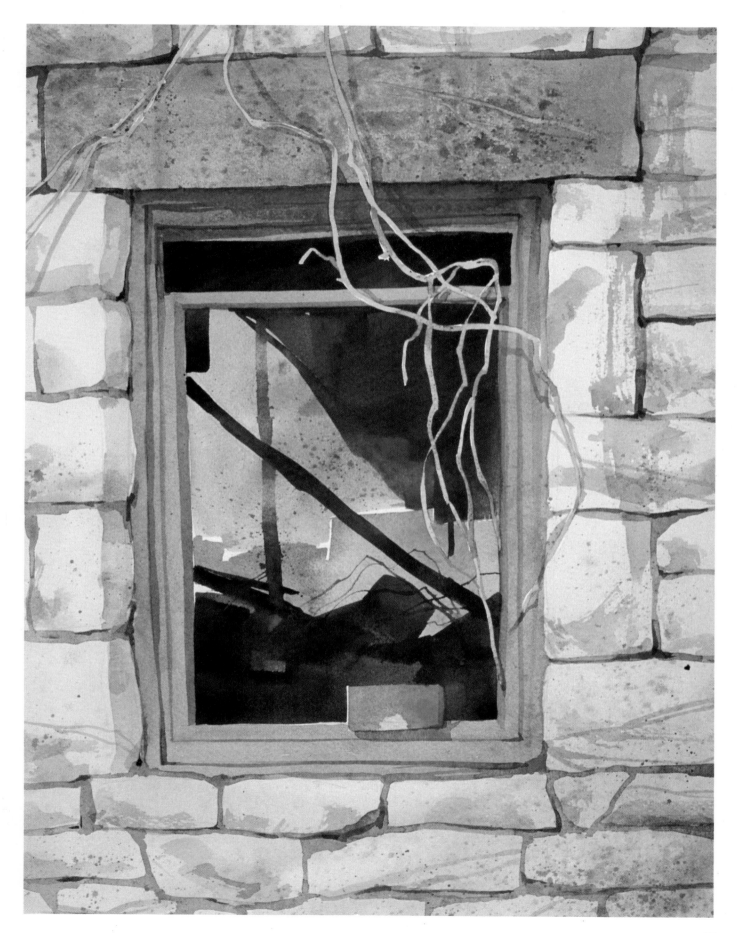

Waxed Paper

Waxed paper is very similar in use to plastic wrap but with somewhat more subtle results as well as a few unique to the paper. I like it even better than the plastic.

Like plastic wrap, you lay it into a wet or just-losing-its-shine wash and allow it to dry for varying lengths of time. It may be laid flat or crumpled tightly for a crackled texture. If you allow it to dry completely—and this can take twenty-four hours or more—some of the wax will be pulled away in the dried pigment. This can be buffed to a slight sheen to add interest to your painting surface.

Waxed paper seems to accentuate the texture of your watercolor paper. As you can see, my favorite paper has a slight cloth-like effect that is played up where the waxed paper is pressed tightly against it. It's nice.

A graded wash of ultramarine blue and alizarin crimson were laid down to show the effect on dye and sedimenting colors; then a flat, smooth piece of waxed paper was laid on top and allowed to dry in place. Even though it is waxed, the paper is still somewhat affected by moisture and is slightly permeable, so it wrinkled just a bit as it dried, making subtle, hazy effects. This might make a nice sky effect, or a soft fabric.

The same pigments were used with a crumpled waxed paper overlay for a totally different effect. A weight was placed on the paper to maintain contact until the wash had begun to dry, then the whole was lifted after twenty-four hours. Notice how the blue pigment puddled somewhat along the edges of the wrinkles. I polished some of the red area with a soft cloth, an effect that may not be visible in reproduction but catches the light nicely.

Now I've used ultramarine blue and burnt sienna with a waxed paper overlay that has been allowed to stay on only a few minutes. The texture is softer, hazier. It reminds me of wet sand by the beach, perhaps.

I've used the same sedimenting colors, but let the paper dry in place—it is a rocky feel, to me, something like marble or granite. The texture is finer-grained than plastic wrap—a nice effect.

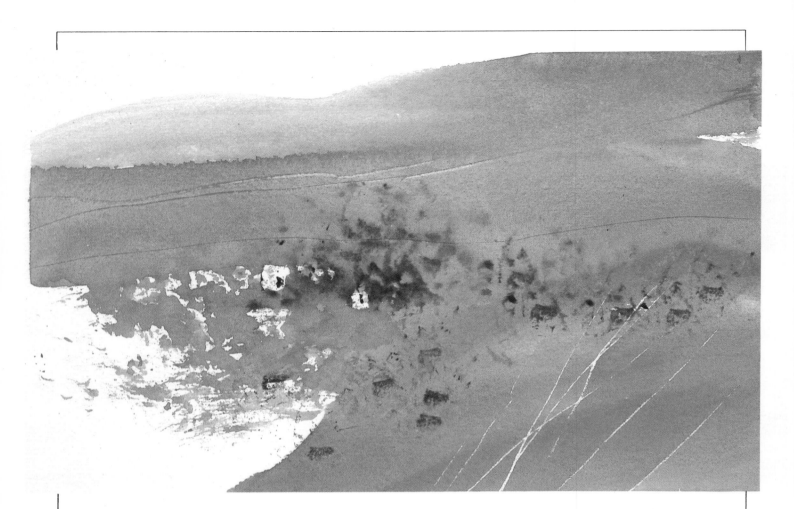

I've branched out into several possible techniques, still using that handy waxed paper. The lines in the lower right were made by laying the waxed paper over my untouched watercolor paper and drawing through the overlay with a pencil point. It laid down a fine line of wax, which then resisted the subsequent wash and left fine white lines. Since they are waxed, it is impossible to paint them with another color—the wax resists that, too—but the white lines are very nice as they are.

In the center, I've stamped my crumpled waxed paper into the colors still on my palette and briskly dabbed them onto my paper into wet and dry areas.

Burnish over waxed paper with a larger tool (a dull butter knife, a burnishing tool, the back of a spoon) for wider areas of resist. Remember, you will not be able to make pigments stick to this area—be sure you want it to remain white.

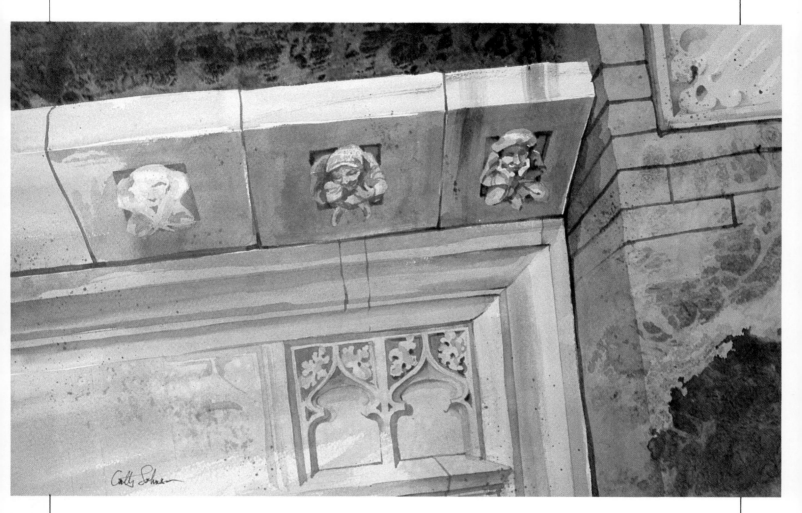

In this painting, I wanted the area of the brick to be quite textured, but with a freer effect than I might have been able to create with my brush. While the strong sedimenting washes were still very wet, I crumpled up waxed paper and pressed it into place, weighting it down until nearly dry.

To preserve the light-struck heads of the little gargoyle figures, I touched each with white paraffin wax to repel subsequent layers of paint; this gives a more subtle effect than masking them out. I wanted to avoid the sometimes cut-out look frisket can give. Positive and negative spatter were added to the blue-gray washes while still damp.

Aluminum Foil

Aluminum foil can be used in ways similar to waxed paper and plastic wrap, that is, pressed into a damp wash to texturize it.

If you are branching out into acrylics as a water-based medium, foil can also be collaged onto your paper and painted over directly for metallic effects.

Foil was used in a texturing technique and allowed to dry in place. No crumpling of the foil was done in this instance. Notice the scratches in the center that were incised *over* the foil and into the wet wash.

This time, I wadded the foil first, then pressed it in place on a damp wash and allowed it to dry. Notice the sharp edges where the creases have been in contact with your paper. How does this effect compare to Saran Wrap used in the same way? To waxed paper?

I wanted to see the effect of flat foil on hot press paper. This time, I allowed the foil to dry for only a few minutes and pulled it away—it's a nice monoprinting effect.

This time, foil was used for a more subtle texture and removed before the wash was dry.

Now I've folded the foil to make a grid effect. This could be an interesting background for a nonrepresentational piece or appreciated strictly for its abstract qualities. Try accordion pleating the foil or otherwise manipulating it to explore different effects. Unlike Saran Wrap, the foil will hold these folds, allowing you to decide beforehand on the effect you want, at least within limits.

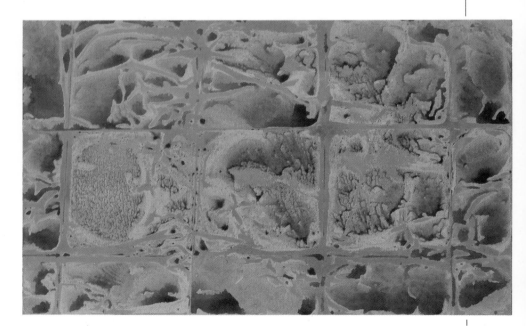

A fabric-like kitchen wipe made several textures worth exploring further. On the left is simply a wash that was stamped (*and* blotted, given the absorbent nature of the wipes) until almost dry. The gray pattern in the center is the mark made by laying a piece of the wipe flat on my palette, then applying it to my paper, and on the right is the effect of stamping with a wadded piece of the same fabric.

This texture was made by laying a piece of rubber-nubbed fabric into my wet wash—it's the kind of fabric intended to be sewn into the feet of kids' winter sleepers to keep them from slipping on hardwood floors! A similar effect might be made with a rubber mat or drain stopper.

My rag bag yielded this ancient bit of seersucker fabric—I liked the linear, bumpy stripes it made when I pressed it into the wet turquoise wash.

Thread, String, and Yarn

You may like free-form linear effects that are difficult to paint with a brush. Consider "stamping" with pigment-soaked string or thread, or even rubber bands. You'll be surprised at the variety of marks made possible with these homely tools.

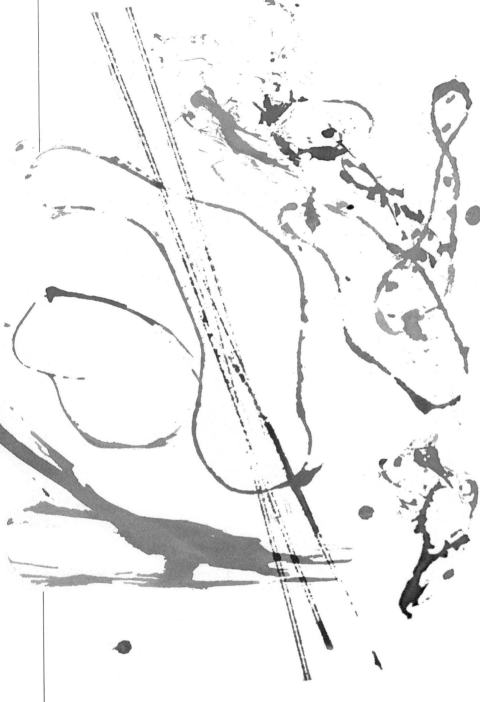

I've made different marks with various colors to help you see what is what. The red amoeba-shaped marks were made with paint-covered rubber bands in two sizes. These come in an amazing array of shapes and sizes—check with your local office supply store. Upper right, I've soaked the string my daily paper was wrapped in, and switched to blue. The shapes are still organic, but the much more absorbent string makes a different effect from the rubber bands. I scrubbed over the paper with the wadded string in the center, and at lower left, still using my blue strings, I laid them in place, then dragged them off to one side. Lower right, I pressed wadded thread into a puddle of my green paint and then onto my paper. It had to be patted down to make contact with my paper; this might be a good place to apply a weight and let it set until dry. The straight burnt sienna lines, in the center, are trimming braid. It was held taut and pressed to the paper. I liked all these unexpected shapes and vital lines. They can be used for telephone lines, a ship's rigging, flower stems, seaweed or kelp, and much more.

Tape

Before there was liquid frisket, artists used masking tape to preserve whites—and it's still an extremely useful tool. It can protect already painted edges as well. For example, you may be planning a large wash right next to a carefully rendered area and you don't want to take chances.

These days, I prefer drafting tape if I can get it. It is less tacky and less likely to damage my paper as I pull it away. An inexpensive brand of masking tape often works the same way. With care, even the better brands can be used safely; just carefully pull the tape away at an acute angle when finished.

I've left some of the masking tape pieces in place so you can see how well they work to mask whites out of a watercolor wash. Some pieces were torn and others were cut with a pair of scissors. One artist I know puts a large piece of tape down on her drawing board and cuts shapes from it with the tip of an X-Acto blade; then she peels them from her board and places them on her paper where needed.

Either way you cut it, you can then paint directly over the protective tape, let your wash dry, and peel it off, leaving a perfect white to be painted—or not—in any way you choose. Consider this for fence posts, the pickets of an old-fashioned white fence, a window in a faraway farmhouse you plan to color later, a sailboat's hull and sheets on a blue sea. You can get much sharper edges with masking tape than seems to be possible with frisket. It's also less tedious to apply. However, loose, free effects, such as you can get with frisket and a brush, are *not* tape's tour de force. Consider your use before you choose your masking medium.

Now I'm using hot press paper for a quick demonstration. Some pieces of tape were cut and others were torn along one or two edges. This is only a sketch, of course, but you can see how useful it might be. *Now* you can buy masking tape circles—I wouldn't have had to mark and draw so carefully to preserve my sun.

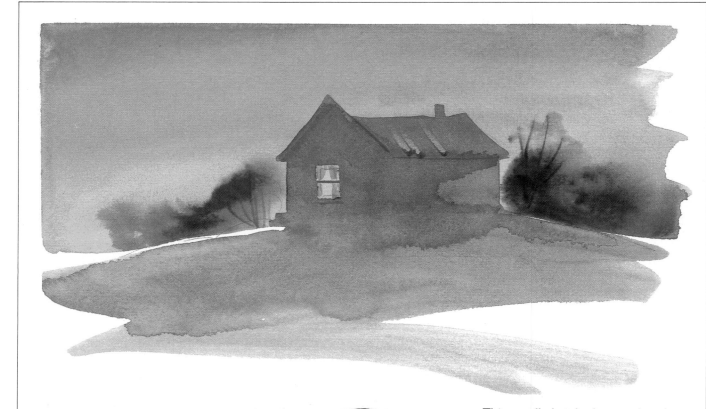

This small sketch shows a handy use for masking tape bits and pieces. I first painted the bright sky and the warm bushes and let them dry thoroughly. Then I masked only the tiny window, using two little squares of tape carefully cut and positioned in place.

Next, I painted the house and snowy hill, and when that was dry, I removed the tape and suggested the lamplit curtains.

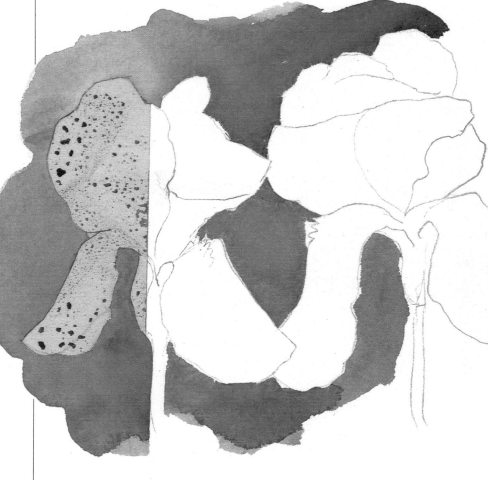

For more complex shapes, you may want to cut your tape directly *on* your paper, being careful to cut through only the tape and not your paper. Drafting tape is better for this than masking tape—it's easier to cut and you are not as likely to damage your paper when you pull it away. I've left some of the tape in place so you can see much better how it works. Both drafting and masking tapes are just translucent enough to see your pencil line through—just cut along the line, pull away the excess tape and paint.

Paper Towels and Tissues

Artists through the years have discovered the indispensable paper towel. Tissues are just as handy. After my time of employment at Hallmark Cards, I found I had developed the habit of holding a tissue in one hand and a brush in the other. That way I could instantly adjust a wash, soften an edge, blot up a spill, lift excess moisture from the bead of a wash or dry my brush for lifting or dry brush applications. Paper towels are every bit as useful, if slightly different in some of their results.

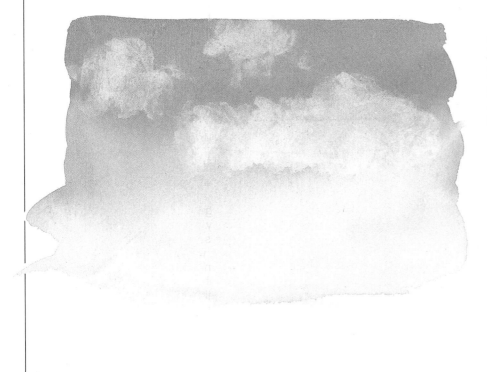

A nice graded thalo blue wash is an obvious place to lift "clouds" with a damp tissue. Notice the soft edges on this sample.

A *dry* tissue blotted this wet wash—the edges of the cloud forms are harder and the clouds are less white. That is because a dry tissue is less absorbent than a damp one—seems just the opposite of how it should be, doesn't it?

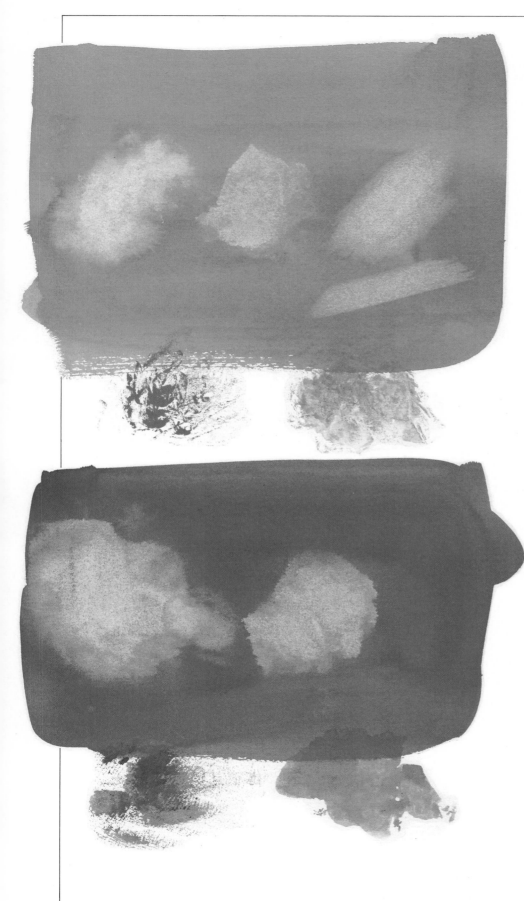

Here, I've used the rather opaque cadmium red to demonstrate the effects of tissue blotting and lifts. At left, I've lifted with a damp tissue—the edges are soft and the paper below is almost white. At center, I blotted with a dry tissue, same amount of pressure. It was unable to lift as much pigment away from the surface, and the edges of the blob are much harder. On the right I let the wash dry thoroughly and lifted with a damp tissue, rubbing my paper gently and blotting away the loosened color with another tissue. The edges are soft, but as you can see, I was unable to get as close to a clean white as I was before the wash dried. The lower streak shows the effect of a hard-edged template to rub against, if you should want a clean line. Blot immediately.

The blotches below show painting with a dry and a damp wad of tissue, respectively. This makes some lovely textures; imagine it in siennas and umbers.

This is the effect of paper towels on an alizarin crimson wash. The towel is rougher than a facial tissue and not quite as maneuverable. On the left I've blotted my wet wash with a damp towel; on the right I used a dry one, and again you can see that not as much color is absorbed by the dry towel as by a damp one.

Left, below is the effect of stamping with a dry towel. You can see the nice texture of the towel itself, which is lost with stamping with the wetter one on the right. Still, they make nice effects—who says you can't paint without sable brushes?

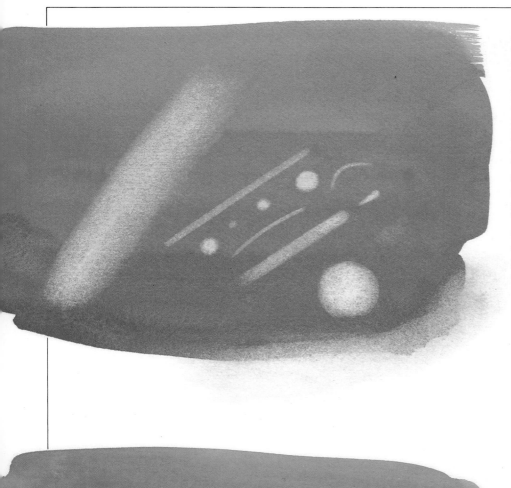

Paper towels are very sturdy and will take a lot of abuse. In this sample I've let my alizarin crimson and ultramarine blue wash dry completely, then lifted the color with a damp paper towel and blotted to remove the loosened pigment (left). In the center I've explored the possibilities of using a template to wash back my color; the smaller shapes were done with an eraser shield, the larger circle (a setting sun?) with a larger circle template. The towels are useful for softening edges, as well. The lower edge had dried completely; I loosened the paint with a damp towel, blotting often with a clean one.

Cotton balls can be used in ways similar to towels and tissues, but surprisingly, are not as absorbent. They *are* strong and sturdy, though, so you can get a lot of use out of a single cotton ball before you have to throw it away. A wet cotton ball holds a lot of water, even if you think you've wrung it out well. The large amorphous shape was the result of blotting quickly with such a dampened ball. Next to it you can see what I mean by lack of absorbency! A dry cotton ball hardly lifted a thing. They are fun for stamping with, as in lower right.

A Thirsty Brush

A "thirsty brush" does not imply that you should take your supplies out for a drink. In case you are unfamiliar with the term, it simply means a brush that has been dipped in clean water, then blotted with a paper towel. A thirsty brush will absorb a lot of pigment, and will allow you more control in a smaller area than many of our other lifting tricks. You will be able to pick out a highlight on a light-struck eye, describe the shape of a petal in detail, push your pigment around, and generally manipulate your painting. A thirsty brush will soften an edge instantly; softening is one of the best uses for those facial tissues.

I've used four blues to give you an idea of the effects you may expect using a thirsty brush; some pigments will move much more easily than others. The dye pigments, for instance, will move while wet, but be virtually impossible to influence very much when dry. Know your pigments as well as your technique to develop a degree of control.

On the left in each color sample I've lifted my pigment while still quite wet with a well-wrung-out brush. As you can see, the effect is very clean on the manganese blue, less so on the others. On the ultra-marine blue as on the manganese, I was able to lift back to a reasonably clean white paper. It was somewhat more difficult on thalo—and, oddly, on cobalt.

At right on our blue samples I've let the washes dry completely, then lifted with a dampened *bristle* brush and blotted away the loosened pigment with a clean tissue. I used the same number of strokes on each sample. As you can see, all of the samples lifted well with this technique but that stubborn thalo; as a dye color, it sank into the fibers of the paper too deeply to lift without some serious damage to the paper surface.

Notice how handy a thirsty brush is to soften a wet edge; this can be invaluable when working from a live model, to capture the softness of flesh.

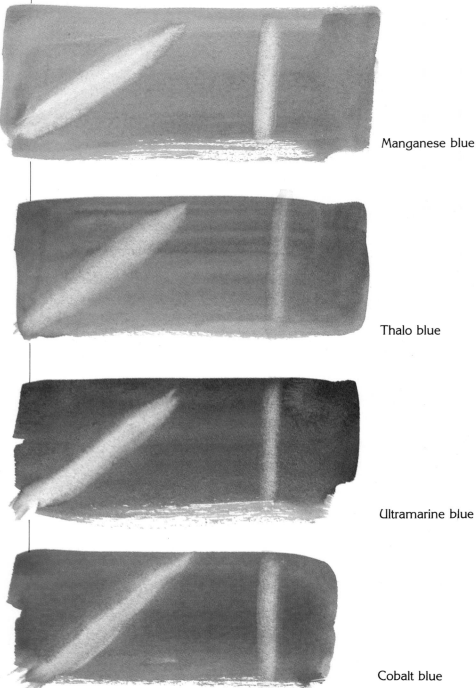

Manganese blue

Thalo blue

Ultramarine blue

Cobalt blue

Sandpaper

At the opposite end of the spectrum from our soft lifts is the effect of sandpaper. It can provide a dark, roughened area or a bold texture; it can even sand your paper back down to clean white surface. But don't expect to paint back over it with the same effects as on virgin paper. Once the paper's fibers have been so abused, they are much more absorbent.

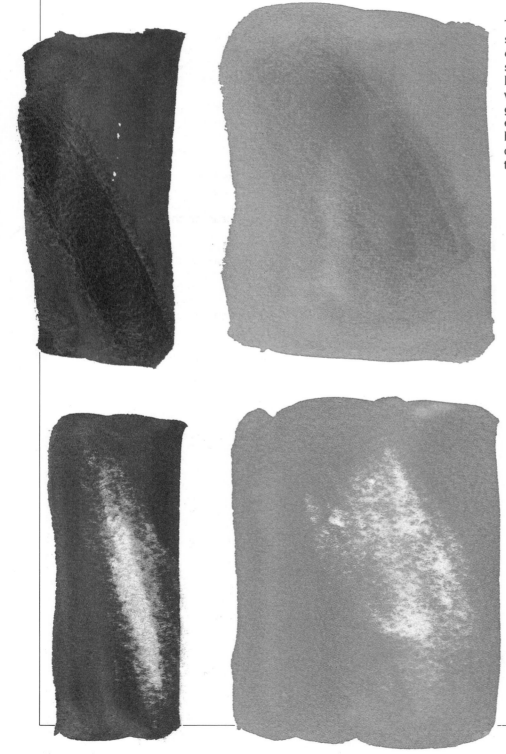

The top sample shows the effect of sanding *before* painting, to make a dark textured area. The bottom sample shows the effect of lifting or lightening by sanding after the washes are thoroughly dry. Vary the grades of sandpaper for different effects. One artist I know punishes her paper with an industrial grade of sandpaper—but it's very effective.

Collage

Using the techniques of collage and watercolor together magnifies the possibilities in many exciting ways. If you are familiar with only one or the other, you may want to try some of these ideas, or think of your own.

Rice paper is a good choice for collage; it's absorbent, semitransparent for veiled, subtle effects, readily available, and lends itself well to watercolor and collage combinations without looking too pasted-on-as-an-afterthought. You can collage anything onto your paper that you like: stencil letters, interesting pieces of wood, metal or paper, thread, yarn, ribbon, lace, foil or foil papers, or even gold leaf.

Cut photographs from a newspaper or magazine and incorporate them into your paintings with a watercolor/collage technique; the possibilities are endless. In this section, I've included only a few to get your creative juices flowing.

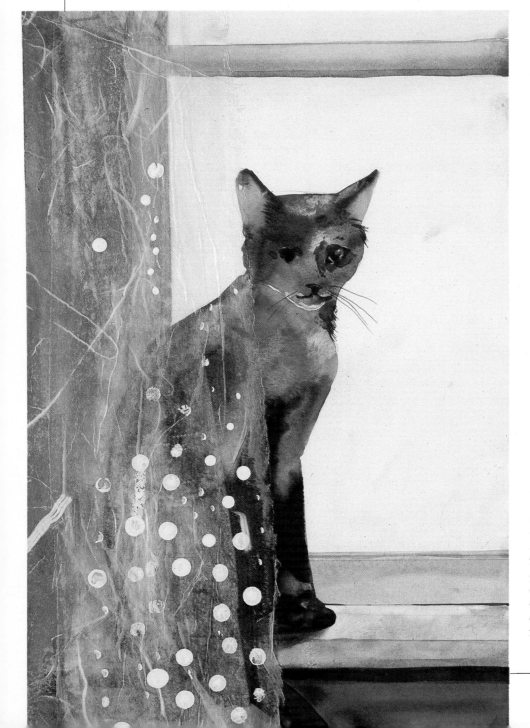

This sketch combines a straight watercolor technique with a bit of collage as spice. The cat and windowsill were painted in a perfectly straightforward way on heavy watercolor board. Then when it was totally dried, I moistened a piece of textured rice paper with polymer medium, lifted it carefully (when wet, rice paper is extremely delicate), and placed it where I wanted it, partly veiling the cat. Bubbles were worked out to the side of the rice paper as I brushed more medium over the top, and additional layers were added to suggest folds in the sheer curtain. As a finishing touch I added a few white dots directly over the rice paper for a sort of dotted effect, like dotted-swiss fabric.

You may also wish to use acrylic as a watercolor medium; it won't lift with repeated layers of collage as watercolor pigment might. I use polymer medium (gloss or matt) or gel medium to attach my collaged additions. The gel medium works better on the heaviest bits.

As mentioned in the section on gesso (Liquid Aids), you can even gesso your chosen collage addenda to your watercolor board, covering them completely and leaving only their textures. This technique is especially effective with three-dimensional objects such as washers, nuts, small nails, feathers, sticks, stones and other natural things; bits of eggshell, straw, grasses, etc. Then you can paint over the dried gesso collage with either abstracted watercolor washes or use it as an interesting surface for a more realistic piece.

This is acrylic pigment used with a watercolor handling. Strong washes were laid down and allowed to dry, then rice paper was laid *dry* in place where I wanted it and attached with a brush loaded with medium. Since I used acrylics for my underwashes, I didn't have to worry about lifting them as I stroked over the paper and beyond the edges. I covered some of the washes with one layer, some with several, and added more watercolor washes on top. The pieces were torn rather than cut so they would have interesting shapes. Look for ways to use these accidental shapes as you work. I hadn't intended, when I started, to end up with a pale tornado shape coming from an angry sky, but my rice paper tore with just such a storm-like tail.

This is a strictly abstract handling of the collage, using rice paper and foil over an acrylic base. I first textured a watery acrylic wash with folded aluminum foil and allowed it to dry thoroughly. Since it was acrylic used as watercolor, I didn't have to worry about this nice texture lifting as I worked, so I cut rice paper squares and attached them with polymer medium in random squares on my grid texture, brushing over and beyond the paper. Then I cut squares of the same folded aluminum I textured with and placed them by painting my surface first with medium, laying down a foil square, then painting again over it to hold it in place. I liked the texture of the rich rose washes on the foil where my texturing had dried. Since it was acrylic, it didn't wash off when I painted over it with my polymer medium. This would have been nice with gold leaf, too, but a bit more difficult to handle since gold leaf is so extremely delicate.

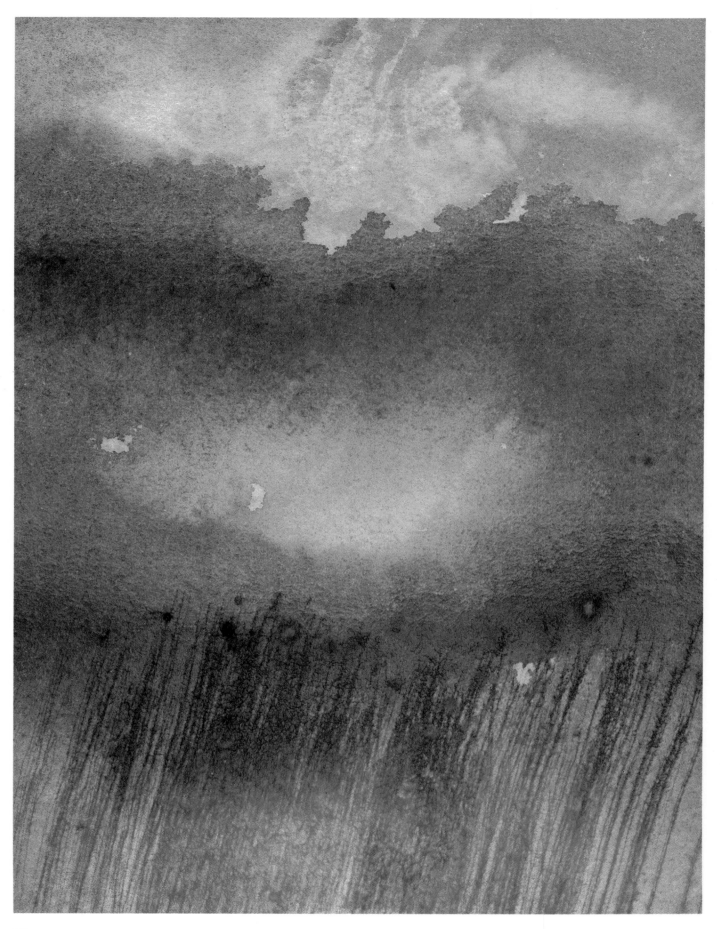

Special Tools

Broadly speaking, a watercolorist's resources include everything from his paper and pigments to his own unique vision of the world. Here I have tried to narrow down the term "tools" to those things we hold in our hand and paint with, mark with, scratch or scrape with, or otherwise use to cause an image to appear on our paper.

In this section you'll see a wide variety of tools and all the different effects they produce. Of course the real magic when using any tools occurs when you use your imagination as well.

First and foremost among an artist's tools, of course, are brushes. These are the most versatile and easily available of any tools we can lay our hands on; they are basic to our work as painters. Learning how and when to use them will allow us to create very nearly any effect we want.

Flat Brushes

Flats are among my favorites for everyday painting. I like the slightly puddled washes I can pull with them and the unexpected effects. I like their versatility, too. Don't think because a brush is square as a board on the end that your strokes have to be, too. Paint with the end of the brush, or the side. Manipulate the body of the brush for varied strokes. Scrub it into your paper. Push up; pull down. Jab and poke your brush at the paper for new effects. (I know this sounds terribly hard on a good watercolor brush. You'll be happy to find how much less expensive the flats are than the round brushes—something to do with ease of construction, I expect. Even a nice big sable flat is much less expensive than a round in comparable size.)

Now I've done the same thing with a flat brush. I used a ½-in. brush for these samples; I also use a ¾-in. and 1-in. in my work. A Flat strokes made with the ends of the bristles. This could be useful to depict anything from a slanted roof to barn boards to wood grain. B A corner of the brush makes tiny dots. C I stood the brush up on end and wet just the tips of the bristles. D I'm using the tips of the bristles to make a wavy line. E The outside edge or side of the brush will make nice, broken, dry-brush effects. F A stairstep or checkerboard effect, taking advantage of the shape of the brush itself. G The ends of my bristles can be used fo stamping. H I'm branching out, turning my brush this way and that using the side and tip at once. I Marks resembling windows made with flat strokes. J Curves of varying widths. K Repeated quick strokes. L Drybrush squiggles. M Thoroughly wiped, the side of my brush will make beautiful open marks. N I especially like the way a flat brush gives just a bit of variation to a flat wash. O My brush was dried on a tissue and jabbed upward to create short "grass."

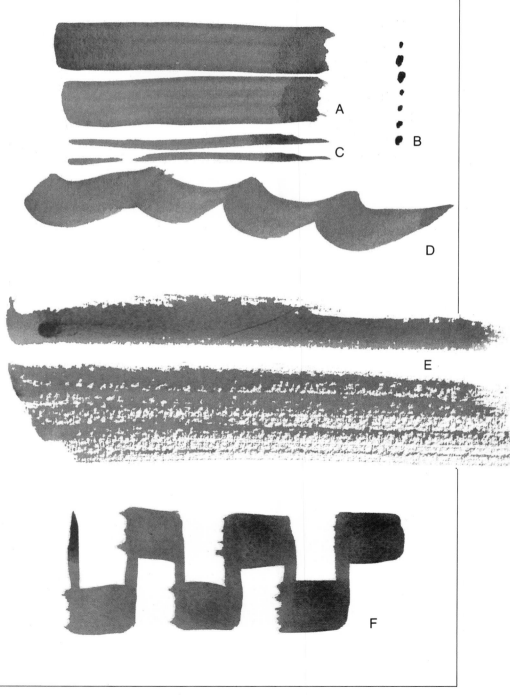

90

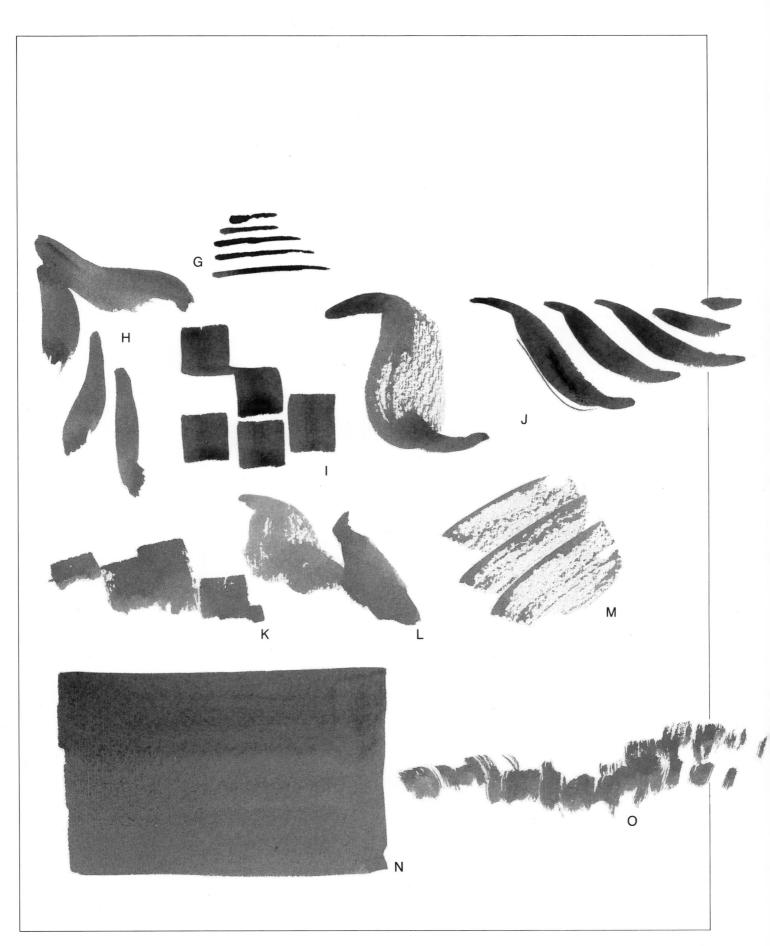

Special Brushes

Don't stop with flats and rounds, however. Riggers or liner brushes, fan brushes, oval sky wash brushes, mops, bristle brushes, stencil brushes—they're all fair game to get your own brand of special effects.

We all have our special favorites. Don't feel you must spend a fortune on a whole quiver-full of brushes. My own favorites are a wonderful Strathmore Kolinsky #12; a ¾-in. flat with aquarelle handles for scraping; a barbered fan brush; an ancient stencil brush for spattering and rough effects; and a couple of riggers I've used for years. Yes, the #12 does cost a king's ransom. For me, it's worth it.

Practice playing with all your brushes to learn just what they are capable of doing. Even if you're an old hand at watercolor, it never hurts to go through a few exercises just to warm up. There's always the chance you'll discover a bold new stroke you didn't know your old brushes could pull off!

A

B

C

D

E

F

Fan Brushes

A fan brush is meant mainly for oil painting, and is often called a blender. For our purposes, I trim the end of mine in a close approximation of what I did to my bangs when I was four—I make a jagged edge. This keeps the marks from becoming too mechanical. A I've made graceful strokes to suggest hair. B The bristles of my fan were jabbed upward to suggest rough grasses. C Stroking downward instead gives a more manicured, controlled effect. D Jabbing with just the tips of my bristles gives a nice texture that could suggest short grass, mosses, lichen, rock texture, gravel, and so on. E I've used the edge of my fan to suggest more grassy forms. F A woodgrain effect is a natural.

An artist I know uses his fan brush to paint the bare twigs on a winter tree; it's a very effective use of this tool. Be careful, though, not to let your effect get too uniform.

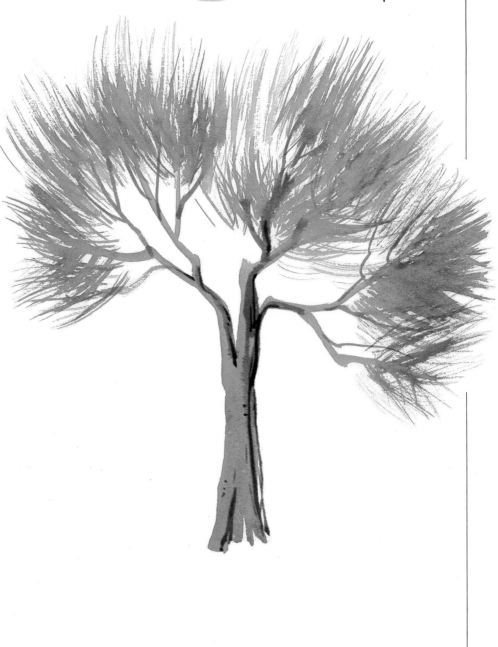

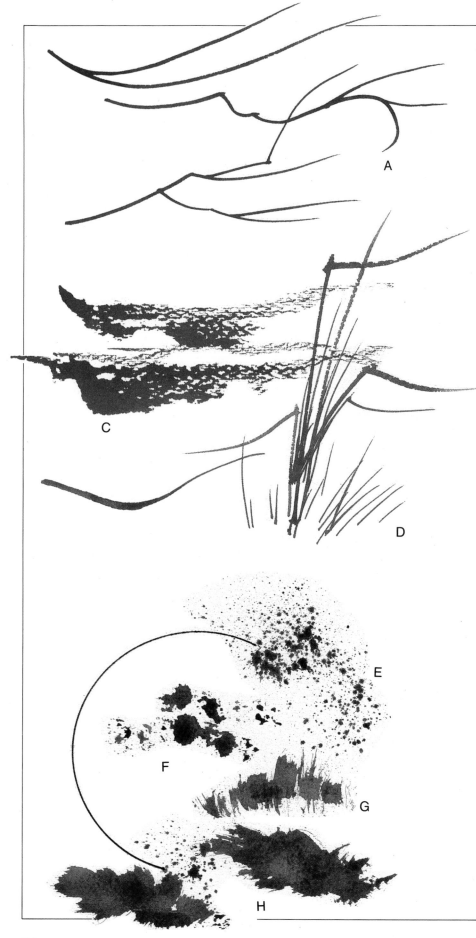

Riggers and Stencil Brushes

Riggers and stencil brushes may look odd, but you'll find them indispensable for many uses. Here, I've used blue for rigger lines and burnt sienna for marks made with my stencil brush. An old toothbrush might be your favorite tool instead. A Notice the nice, uniform, sweeping lines that are possible with a rigger or liner brush. I often use them to suggest bare twigs—the line fairly dances as you change direction. B My spiral was interrupted by a curious cat! C The side of the long rigger bristles produces a creditable dry-brush effect. D Long weedy grasses look natural painted with a rigger. E My favorite use for my stencil brush—spatter. I use this to suggest texture in many applications. Try it for old boards, a sandy beach, rough soil, sparkles on water. It gives the feeling of texture without the temptation to overwork. F I've switched to my ancient stencil brush; you may prefer a toothbrush or stiff-bristled brush intended for use with oils for this. Here I have jabbed with the ends of my bristles. G An upward stroke gives the feeling of rough grasses. H You can even paint with your stencil brush just as you would any other, for rugged effects; I was going for pine boughs, here (so perhaps green *would* have been a better color choice).

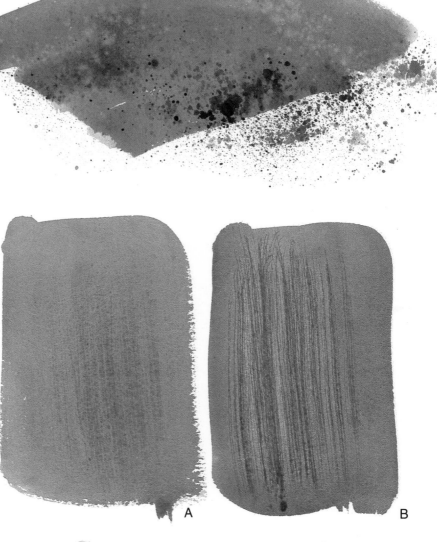

I use the end of my thumb run over the bristles to make the spatters fly off my brush (and always look as if I'd been working on my car). Other artists may like an old pigment-loaded toothbrush run over a piece of screen wire, but I find that effect a bit too regular. Clump your spatter rather than making even droplets all over an area; it's more interesting and looks more natural to have some variation (lower right).

I also use clear water to spatter into a wet wash (upper left) for variations in texture. Blot, if you like, with a tissue to play up the blotched effect.

Spatter color into a wet wash for softer effects and continue to spatter as your wash dries. Blot here and there to assure a variety of values.

Utility Brush

This next brush requires a bit of explanation; it's a small, brass-bristled brush used for cleaning your barbeque grill—look in your local hardware store for this handy tool. Some have a scraping edge that make them doubly useful—you can lift or push paint around with that edge. A I've scratched before painting to bruise the paper slightly—the effect is very subtle. B When you scratch into a wet wash you can get much bolder lines, as the paint sinks into the damaged paper fibers. C I've suggested one possible use for the wire brush—falling rain. You might also use it to suggest grass, hair, wood grain, or simply a nice texture in an abstract composition. Try crosshatching into a wet wash for a fresh look. Suggest a linen weave in a portrait subject's clothing. It's a handy brush.

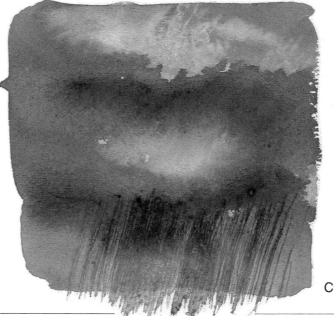

A

B

C

Spray Bottles

Some sort of spray bottle should be a part of your permanent tool kit. They come in all shapes and sizes and degrees of portability. Spray bottles can dampen your paper for a wet-in-wet effect before painting. I just hit my paper all over with a clear-water spray, then spread the water lightly with a brush. You can also fix mistakes, or keep an area damp that threatens to dry before its time. If your watercolor board begins to warp, making your washes threaten to run off at the sides, get out your sprayer and spray the back of the board with clean water; it'll straighten right up, since the back side will stretch to counteract the curve of the front.

Watercolorist Nita Engles swears by an empty Windex™ bottle; I have an industrial-cleaner sprayer that makes a nice fine spray. In my daypack I carry a tiny perfume atomizer that will perform the same tricks and is more portable. Look around your studio; I'll wager you'll find something close to home.

You can make interesting textures with spray bottles, spraying a wet edge to make it explode, spraying a drying wash with clear droplets, or even loading your sprayer with a wash and using it like an airbrush.

Here are two very different effects from spray bottles. The ultramarine blue and sap green blob demonstrates what happens when you allow a wash to lose its wet-wet shine and hit it with droplets from your sprayer.

A cadmium red blob has been manipulated in several ways. First, while the wash was quite wet, I sprayed the lower edge with a couple of shots of clean water. The pigment bled down into this new, odd shape and made interesting lacy edges—it would make a nice bit of foliage if it were green.

I sprayed my wet wash and blotted quickly in the center—this made a dramatic change in value and reminded me of another trick.

I dropped two identical drops of red paint beside my big red blob in the small circles. I just blotted the top one with a damp tissue, but on the lower one I sprayed the droplet first with clean water, then blotted—it came very nearly clean. I once saw artist Jim Hamil save a painting in just that way—it's too good not to pass on.

Oh, the pink cloud circled in the middle? I loaded my atomizer with a pale alizarin crimson wash and gave it a spray. It's a bit less delicate than the effects you can get with an airbrush (all right, a *lot* less delicate) but it could be handy, and at $1.29 for the atomizer, it's a lot less expensive as well.

Fixative Sprayer

An old-fashioned device, the fixative sprayer looks like two metal straws hinged together, one slightly smaller than the other. And in fact that's just what it is. The smaller straw is dropped into a small jar or bottle of fixative/water/paint and you blow into the larger one, which you've bent to form a right angle with the small straw. Don't ask me why it works—I'm no physicist—but your breath blowing past the hole in the small straw draws up the liquid. If you are windy enough, the force of your breath will blow the liquid evenly over the paper you're aiming at. Hold the paper closer and you get interesting "flowers." This little item is *much* less expensive than an airbrush, and if you don't plan to use it often it may be just the trick. If you suffer from emphysema or asthma, though, forget it—it takes a lot of force to move the paint and keep it moving evenly.

My small metal fixative blower made these airbrush-like effects. I simply mixed up a small wash in a little container and sprayed it onto my paper from varying distances. The "flowers" were made from less than 3 inches from my surface; softer effects are possible if you move away from the paper. The harder you blow, the finer the particles will be.

Drinking Straws

Ordinary soft drink straws are handy for painting in several ways. You can blow a puddle of paint around in nice amoebic shapes; you can paint directly from the end of the straw by filling the tube with a wash, then holding your thumb over the end till you want to release it; or you can stamp or print with the straws.

The big red blob was pushed around by blowing through a straw, changing my direction at will. These blobs are useful for rough textures such as tree bark or rocks. You can have more or less control, depending on how hard you blow. On the left I've stamped with the end of the straw, and on the right I've used it to draw with, as if it were a pen. If I were extremely steady-handed, I could cut a nib in the end of my straw in the way that our forebears used to make quill pens.

Hair Dryer

Of course the best use of the hair dryer is to dry things. I often use mine to dry washes. If you, too, are the impatient sort, give this a try. Be sure to keep the dryer *moving* and at least 18 inches away from your work, to avoid moving paint around inadvertently or creating hard edges where you don't want them.

Here I've made a big puddle of juicy blue and directed the runs with the stream of air from my hair dryer. This would work well for abstract effects. It does take a dryer with a strong stream of air; mine was almost too weak to make things move much.

Erasers

Erasers are good for more than obliterating mistakes when you are writing or drawing. You can lift washes to reestablish whites; if you are careful, and use a fine eraser, you can even paint back over the area you have lifted.

There are a number of alternatives with erasers. Check out your office supply store as well as art supply store to see what kinds of erasers are available. I have an invaluable *electric* eraser that will lift back to white paper, if needed. Of course it is rather expensive, and if I didn't also do a number of pen and ink illustrations I might not have invested in this tool.

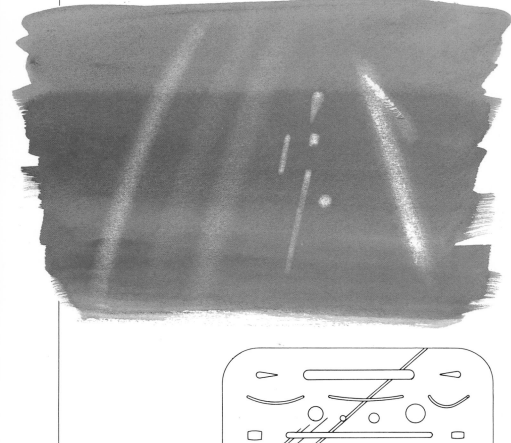

I laid down a wash of staining alizarin crimson plus two sedimenting colors, ultramarine blue and burnt umber, and allowed them to dry thoroughly. Then, starting on the left, I used an ordinary pink eraser on the end of my pencil. It was a bit rough on my watercolor paper, but it did manage the lift. Next, I tried a very soft film eraser and had almost no effect, although if I had kept at it, probably it would have eventually lifted a bit more. It might be useful for modeling subtle areas. Then I used a white eraser in pencil form. It was less effective than the pink eraser, but was also easier on my paper. Next, I got out my electric eraser and eraser shield; you can see that in short order I was able to lift almost back down to white paper. (Note the eraser shield below—it's an extremely handy tool.) Finally, I used an ink eraser; it's very effective at removing pigment, even the dye color, but it is hard on the paper.

One artist I know erases back an arc in his skies, then draws or paints in a soft rainbow when everything is dry; it's a nice, subtle way to handle what often becomes a garish mistake.

Scratchboard Tools

There are a lot of ways of regaining lost whites, of course; you don't have to rely solely on your eraser. Scratchboard tools are one of my favorite ways of regaining linear whites.

These tools, as their name implies, are meant to be used with scratchboard, that clay-coated board we experimented with earlier. They can also be used on watercolor paper of any weight to scratch through washes. If you work into a wet wash, you will incise *darker* lines where you have bruised the paper fibers, but if you wait until the wash is dry you can get nice linear, light-struck effects with these tools.

There are two types of scratchboard tools, which give slightly different effects. One is a small, pointed tool with a flat blade. Its effects are more jagged and spotty (on the left) as that sharp point bites into the paper. The other is a rounded, spoon-shaped tool that makes softer effects, thanks to its rounded tip.

Craft Knife

I use my craft knife for more than cutting my paper and matboard; it, too, is a handy tool for regaining whites in a watercolor. It can be used like the sharp scratchboard tool or in more controlled ways, to cut and lift away the top layer of your paper for a perfectly white area. It is difficult to repaint on this white, though, since it is rougher and more absorbent than the original surface. It may work best to reserve the use of a craft knife for those places where you really want only a pure white.

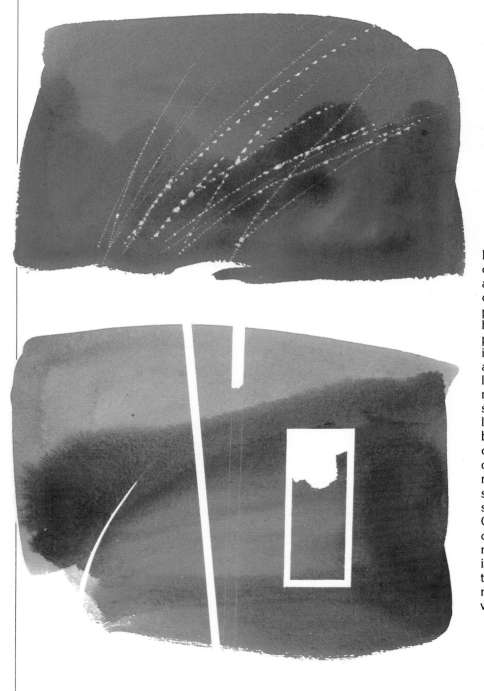

This sample is very much like the ones made with scratchboard tools, and it is indeed made in the same way. Allow your wash to dry thoroughly, then scrape the tip of your knife over the painting's surface. Vary the pressure you exert to vary the line width and effect.

Now, I've gone on to more mechanical effects, using the point of a very sharp craft (X-Acto) knife. I cut through the top layer of my paper, and lifting with the point of my blade, I carefully work the thin, painted layer up. At left, I've approximated a light-struck blade of grass, a hair, or other linear form. Center, I've shown how you can make quite rigid shapes by cutting along a straightedge if you need to. I began lifting at the outer edge of my gray-brown blob and left it torn off in the center, so you can see a tiny layer of paper really is cut away. This might be useful to suggest light streaming in through the boards inside a barn or as a picket fence. On the right I've suggested a window shape, using this same technique. There are times when we all inadvertently paint over an important white; using this technique you may be able to regain a window, a white sail, the light in an eye . . .

Other Scraping Tools

There are times when you don't want to scrape all the way back to white; you just want to create a texture or suggest a lighter area. The trick to using scraping or lifting tools is in the timing. If you scrape when the wash is wet you will be able to make areas darker than your body wash. By waiting until your wash begins to lose its wet shine, you'll be able to push the pigment out of the way to make lighter areas. Depending on the tool you choose, these areas can be as small and narrow as the stem of a weed or as broad as a granite boulder. I have seen whole buildings suggested with a single stroke of a lifting tool.

What should you use for this purpose? Many flat brushes are made with an angled, plastic handle end that can prove extremely useful. Or try an old credit card, cut to various widths, a plastic spatula from your kitchen, or your fingernail if nothing else is handy.

I used the end of an aquarelle brush to make these lines in a damp wash. On the sides, the wash was still quite wet, causing the lines to appear darker; at the center, I actually pushed the paint out of the way with the end of my brush.

A

B

C

D

Experiment with other scraping and incising tools to see what effects you can come up with. Here, I've used a plastic kitchen scraper A, an old credit card B, the end of a round watercolor brush C, and my fingernail D to lift and manipulate pigment. These effects can be valuable when suggesting the texture of hair or fur, grasses and weeds, rocks in a landscape, buildings in the distance, or simply lighter forms. Single edge razor blades can give many of these same effects; if you should break an edge, don't throw away the blade, simply use it where you want a narrower lift.

Knives

Knives of all sorts are handy in creating a variety of textural effects. A blunt edge of a butter knife works well to lift or push pigment, as our other tools did, but you can also create a number of incised effects by bruising the paper fibers.

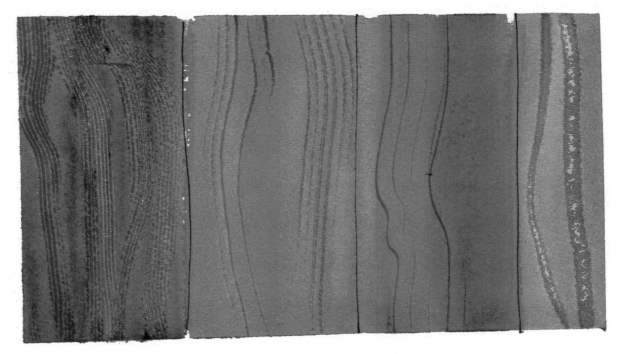

Top right: Here is a variety of marks made by three different types of knives. At left are marks made by a widely serrated plastic knife of the sort you'd take with you to a paper-plate picnic dinner; I keep one handy in my daypack. Center, the finely spaced lines are the result of dragging a finely serrated steak knife through a wet wash. It's a bit too regular to use for naturalistic effects, but it would be very useful in a more abstract situation. On the right, I've roughly pulled a rounded butter knife through my wet wash; the pressure was great enough to push the paint in the middle of the stroke out of the way while bruising a darker area along the sides.

Above, centered: This suggests some possible uses for my incising tools; I've created a variety of wood effects by simply incising while the wash was wet. From left to right are the steak knife, the plastic serrated blade, a dinner fork, and the blunt butter knife again.

Paraffin or Crayons

You may wish to plan ahead to retain whites with tools. Crayons and old candles can give a fine line. A block of paraffin can give you as bold a light as you could wish. Since they are wax and resist further washes, be sure to apply them only when you are sure you want the effect, either before painting to maintain a white or at any stage in between to protect the color of an underwash.

Batik-makers have known for centuries that wax repels waterborne dyes—why not use that knowledge as watercolorists? In "liquid aids" we covered a more truly batik-like technique; here, we'll explore ways to use the dry form. A block of paraffin, a white candle, a child's wax crayon—anything will do. You may wish to try oil pastels for a mixed media effect; the pastel lines will resist the washes just as in any of these other techniques. My samples were done with a small utility candle; if you prefer color, break out the crayons!

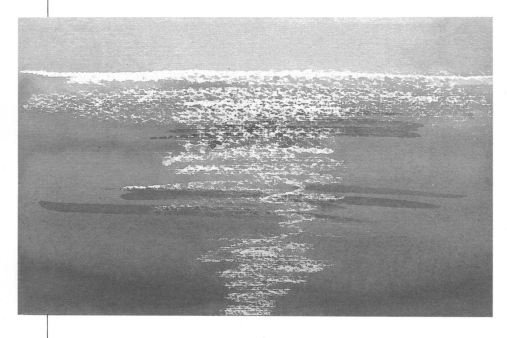

Here the edge of the candle was used in a linear motion; obviously I was thinking of a placid lake with the glitter of sunlight. You might use your candle to retain lights on a rain-slick street, the shine of a young girl's hair, highlights on foliage. I used alizarin crimson and thalo blue that played up the placid-lake effect; try it with rich darks or warm colors.

"Graffiti" is fun with colored crayons, as well; just be sure you use a color that will show up against your overwash. I played it safe with white crayon under my burnt sienna and ultramarine blue. Yellow, orange, red and light blue also work well. I once did a painting of an old doorway in the city (well-marked with the sentiments of the neighborhood teenagers) with my crayon-resist graffiti—cleaned up the wording a bit, though. (See the Techniques in Action section.)

Light trees can be retained against a darker background using wax resist. Here I've used a double wash glaze to see what would happen. The white trees and branches were put down on my paper first (the broad trunk done with the side of the candle; bark scars added with the sharper edge). Then I flooded in a warm golden wash and let it dry, adding a swipe of cool shadow down the side of my big trunk. Then I added more branches and leaf shapes over the gold with another layer of wax and added a darker, warmer wash. This would be good to use on a finished painting—but remember, you won't be able to make any dark lines stick over the wax lines and shapes. Plan carefully.

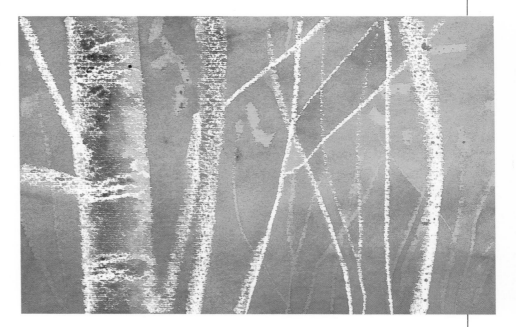

I just wanted to try a variety of strokes with a strong, boldly colored overwash. Really makes those whites pop, doesn't it? You can get more delicate effects using a broken edge of a paraffin block or a sharpened white crayon; or use another color for your wax crayon lines.

Now I've used my wax candle's edge to suggest light-struck planes in rock, with a dark overwash of sedimenting colors (burnt sienna, ultramarine blue) and added a bit of detailing with a rigger. If you don't want your lights to stand out quite so obviously, first put down a light-toned wash of your rock colors. I could have used raw sienna near the top and cooled it with a light wash of cobalt as the rocks turned away from the edge of the hill, for a feeling of volume and depth.

Crayons are a delight to combine with watercolor effects. Use them to suggest graffiti, as suggested, or as a design element in mixed media techniques (again, you may have difficulty entering such a piece in a watermedia show, but don't let that stop you from experimenting—and enjoying it). Here, I've used a variety of colors chosen more or less at random (but keeping their values light to medium) with a variegated watercolor wash. Notice how the colors stand out; some even seem to fluoresce. On the flower I've used a single color as an outline strictly as a design element; I know of no flower in nature with a red outline, but the contrast is irresistible. At lower right I've used more naturalistic handling, with yellow crayon as the outline and veining on a leaf form, and yellow green and green washes added.

Pastels or Chalk

An effect similar to using crayons can be gained by adding pastel or soft chalk lines *after* you have painted. This makes a fascinating, linear effect, useful for an allover design. Or use it in more naturalistic ways. One artist of my acquaintance uses chalk lines as lively outlines that give a special feeling to her watercolors.

I did a large paisley with watercolor washes, then added chalk lines for spark; think how this effect might be used when painting plants or flowers. It is more difficult to control the larger pastels or soft chalks, though—you may prefer to use pastel pencils.

Colored Pencils

An increasingly popular medium, a colored pencil is wonderfully versatile and mixes well with watercolor. You may prefer to use the pencils for sketching, with watercolor washes added (my favorite use), or incorporate the pencils in your finished works. Some artists use them to add spark or details to finished paintings, or to correct areas that have become dull without the danger of making the painting muddy with too many overwashes.

"Sumacs"

JOHNSON

Some colored pencils have a waxy base; these are the ones I prefer for sketching. They will not smear as graphite pencils tend to, even if I rub my hand across a dark area; they also will not lift or muddy my washes.

I enjoy working with a dark gray wax-based colored pencil (Prismacolor or Eberhard Faber Colorama brands are my favorites) when working on the spot. Later, I add watercolor washes, usually after I return home. I find this helps me train my color memory—it also lightens the load I carry with me to the field! This small sketch was made on a Notchy Postcard with a warm dark gray pencil, then completed later.

Here, I have explored more linear, controlled effects with water-soluble pencils. I drew the geraniums using mostly outlines, with just a bit of interior work; the clear-water washes make a nice looseness as a kind of counterpoint.

Right: There are times when a painting just isn't satisfying—especially, it seems to me, when I work in the field. Nature can be confusing, and I often find myself trying to include too much; my painting gets away from me. Rather than rip it up and throw it away, it's worth playing with, using my colored pencils. Here, I added a bit of sparkle in the form of highlights on the water and rocks, to what had become a rather muddy, uninteresting mess.

You may prefer to plan ahead for such an effect—it doesn't have to be a last-ditch afterthought! And these mixed-media paintings are receiving increasing acceptance at shows; they are often more interesting than "pure aquarelle."

Top left: It isn't necessary to limit yourself to one color unless you just want to; this little sketch was made using a variety of colored pencils, with light washes added at a later time.

Bottom left: Other pencils are water soluble, allowing the artist to work in watercolor without the necessity of toting the tubes and water containers into the field. I enjoy sketching with these pencils, as well; the colors are bright and lively. (Get acquainted with the effects of each pencil after it has been moistened, though—some become quite garish when wet.)

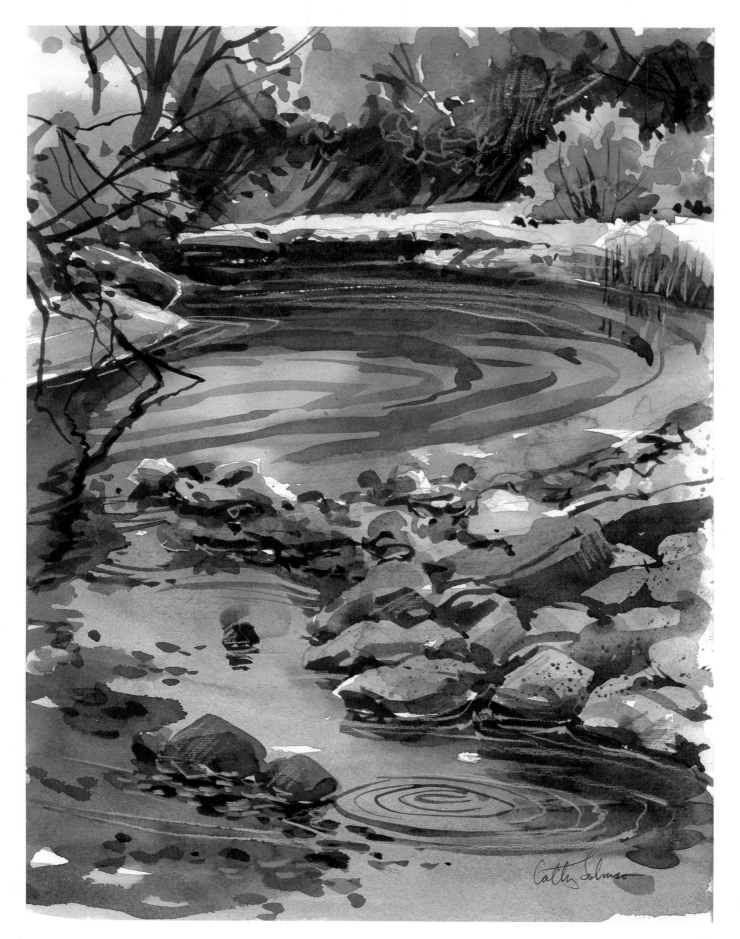

Pencils

I often use graphite pencils to do preliminary sketching before beginning to paint; the lines can add a nice touch if they are left in place rather than erased or covered.

If you prefer to erase your lines, you may have the best luck by erasing them after the first, light, preliminary washes are down; your composition is in place and you no longer really need the visible "bones" underneath. If you wait until later, you may lift some of your pigment as you erase.

This graphite pencil technique seems to work best if washes are kept simple and somewhat high in key; think of the beautiful watercolors of Auguste Rodin or some of Picasso's drawings with washes. They have a simplicity and honesty I really like.

I've used a loose, gesture-drawing technique for my pencil drawing of Ann, my god-child; watercolor washes were kept light enough that the backbone of the drawing showed through. This can be very effective in drawing nudes, flowers, and even landscapes; keep pencil shading to a minimum.

Ballpoint Pens

I like the fine underdrawing possible with ball points. Test your pen line with clear water to find out if it is water soluble (if so, it can still make lovely, unpredictable effects). It *is* helpful, though, to have some idea of what to expect as you work.

Black ink seems to lend itself best to this underdrawing technique, but you may prefer one of the many other colors that are available. I choose brown ink when I want an aged, subtle effect. Be advised that some black inks will fade with time; you may *still* end up with a brown line. It is quite beautiful, though—I don't mind if mine choose to fade.

Again, I kept washes simple, with very little detail except the drawing itself. I have used a permanent black ink here, so there was no lifting as I added washes. Here and there I blotted my wet washes to add a bit of contour and texture.

Ball points are always handy; you probably have one in your pocket or purse right now. Although they may not stand the test of time, don't let that stop you from using them with your watercolors as a sketching medium.

Felt-Tip Pens

Another ubiquitous implement you may not have thought of using with watercolor is the felt-tip pen. It's explosive, unpredictable—and fun! Of course it is perfectly well-behaved if you use it to draw over dry washes, but why not see what will happen when you use it wet?

You don't even have to use felt tips *with* watercolor—you can use them instead. Simply draw on your paper, using as many colors of ink as you like, then wet with clear water. Bear in mind that many felt-tip markers are not light-fast and may fade in time. Permanent felt tips are impermeable by water; they look very much like any ink drawing with watercolor washes, so I didn't include any here.

Fiber-tipped brushes make interesting, varied lines that may be to your taste. Like regular fiber tip pens, the ink used in these brushes is highly unpredictable when wet. The flexible tip of this tool makes marks very much like those possible with a round watercolor brush; in my sample I left some un-touched with paint to show the quality of the lines.

Again, I added my washes quickly, with a very light touch; when I touched a line, the results were explosive. Notice the rather mossy effects near the cat's front leg; this might be useful in a landscape situation, or as an abstract line.

When I used a brush to apply clear water to my lines, they tended to run uncontrollably, sometimes almost washing away. This time, I tried a sprayer loaded with clear water. On the left, I sprayed lightly; then I protected this area and sprayed the right side more heavily. The nice washy effect was almost lost as it dried, leaving light blue lines I had originally drawn in place.

Finally, I tried the razor-point felt-tip or fiber-tipped pens on a hot press paper. This is a technique I use often; the lines tend to stay put a bit better, only softening nicely when wet. It's handy and effective for on-the-spot sketching or studio works.

Bamboo Pens

A bamboo pen is relatively inflexible; the ink or watercolor lines become narrower and fainter as the pen runs out of fluid, making it perfect for a number of naturalistic applications. I enjoy the variable line when painting florals; you may find the strong linear effects handy in any number of ways.

This is a quick sketch of an iris, done with liquid dye watercolors (Luma brand) and a small bamboo pen. Loose washes were added using regular tube watercolors.

You can also use the pen itself to "paint" with, and leave out washes altogether. The small butterfly weed in the circle was done in this way; it can be especially effective if you change colors of ink or liquid watercolor to do each design element. Lumas are perfect for this; they are easily found, come in a wide choice of colors, and are convenient to dip a pen into. If you prefer regular tube watercolors, mix a juicy wash in a small container deep enough to dip into, or load your pen with the end of a round watercolor brush. (See "Butterfly Weed" in the Gallery section.)

Palette Knife

Your palette knife is not made just for oils or acrylics; I use mine exclusively for watercolor techniques. Buy one with a good flexible tip, slightly rounded, as shown. These generally come with a thin lacquer coating to protect the metal from rust or abrasion; before watercolor will adhere to the blade, this coating will have to be removed. Sand it off, using a very fine sandpaper, or use lacquer remover, or hold the blade in an open flame for a few moments to burn it down to bare metal. Any of these techniques will temper the knife for use with watercolor.

Paint will flow off the tip of your palette knife in much the same way it did off the bamboo pen, with somewhat more controllable results. As you paint, the lines become finer, making it a very useful technique to suggest the diminishing diameter of twigs or grasses.

The knife can also be used in a manner very similar to that used in oil painting, using the flat of the blade to "scumble" paint onto your paper's surface, as in the lower left. This suggests the texture of distant grasses, or pine-tree foliage, perhaps.

On the lower right I used the edge of the blade to deposit my paint, making an extremely fine line. Use this wherever you need a longer, uniform line—it is much easier than using a small round watercolor brush.

I use my palette knife to apply liquid frisket before painting, as well.

Sponges

Sponges are extremely handy for the watercolorist, in many ways that I can't show in print. Use them to uniformly wet your paper before beginning a wet-in-wet passage, or to wet the back of a watercolor board that has begun to warp. Keep one handy to your palette to adjust the amount of paint or water on your brush; it will soak up the excess instantly, allowing you to get perfect dry-brush effects.

Use sponges to pick up spilled paint on your floor, your table—or your painting. Adjust painted areas that have become overworked with a soft sponge and clean water, then blot with a tissue. You can even use sponges to paint with; a technique I recommend only with strong reservations; it's easily overdone, and when the results are too uniform and predictable it can be disastrous.

Synthetic sponges can be useful to paint with, too. Some come with a regular texture on one side that can be used for stamping; or try painting with an edge. Some synthetic sponges have a "pot scrubber" side; they will make interesting textural effects if used in moderation.

A synthetic sponge was used for these samples. At upper right I've shown one of the handiest tricks these sturdy sponges can do; they'll remove paint all the way back to white paper, unless you've used a dye color as I have here. Use this to change or modify an area that has become too strong, too busy, or overworked. Load your sponge with clean water and blot often with a tissue or paper towel.

The back of my sponge had an interesting, uniform texture; I used it on the left to overstamp my preliminary washes for a rather abstract texture. Other sponges have a brick-like surface; they're worth hunting for.

The green was stamped with the edge of another sponge, one with a nice large-holed texture. It also had a pot-scrubber surface on one side, and I picked up alizarin crimson with it to deposit it over my paper's surface.

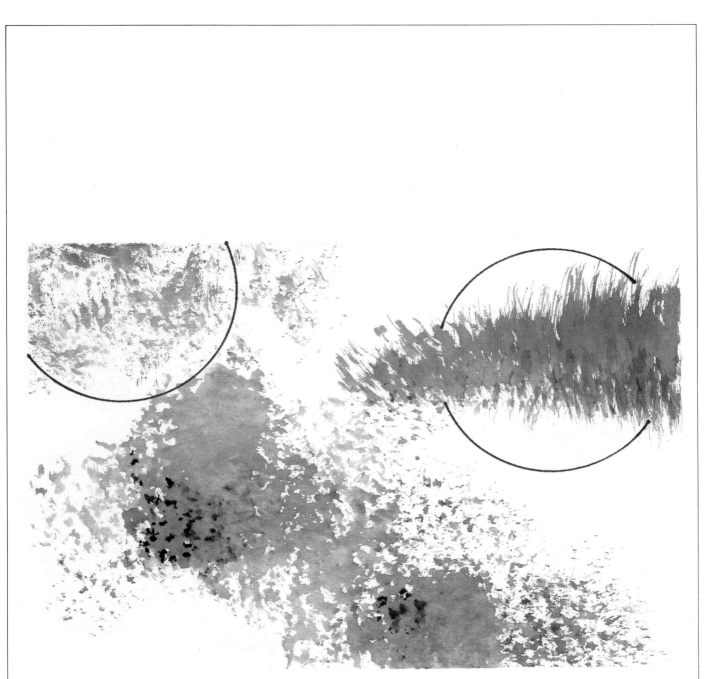

Natural sponges are best for most applications. Twist and turn your sponge and use different areas of its surface to get more interesting, varied effects. Look for the ragged-iest sponge you can find; a hardware store may be a good place to look. It's easy to fall in love with the loose, free effects of a big natural sponge; remember it's a tool like any other, and use it in a variety of ways.

I used natural sea-sponges on this sample; they can be useful for suggesting an overall texture (upper left circle), a grassy effect created with a short, upward stroke repeated several times (upper right circle) or a foliage or lichen-like effect made by jabbing my sponge on the paper's surface, while continually turning the sponge to use a new surface. Try for color variation when you use this technique; dip or dot your sponge into several colors or values.

Stamping Tools

Sometimes a "tooled" effect can be more interesting than a painted one; try stamping your pigment onto your paper's surface for a fresh approach. California watercolorist Rex Brandt gets wonderful effects with stamping; so can you. Use the edge of a piece of mat board, the end of an eraser (or a large eraser, held flat or on edge). Look around your studio and see what might work well for you. You may find that stamped fence posts look much better than painted ones; to vary your line shape, bend your mat board scrap slightly.

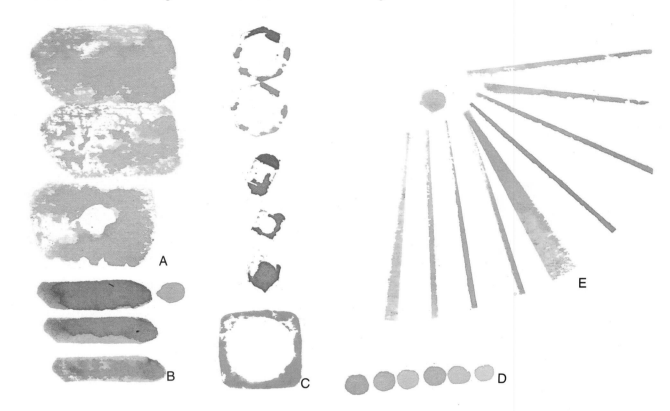

The colors in my sample are bright and cheerful; they seem to go with the nature of stamped effects. At A I've used my soft film eraser, dipped in yellow and pressed firmly into the paper. B is the side of the same eraser, stamping alizarin crimson.

The column of effects at C is the result of looking around my drawing board for things to stamp with;

you can see the end of a broad, chisel-pointed felt-tip container, the ends of several caps, and the design on the tip of a bottle of Liquid Paper™.

At D, I've made a line of "beads" with the eraser on the end of my pencil; these could be used as flower centers, segments of a caterpillar, dots on a woman's dress—a useful tool!

I've used matboard scraps to make the straight marks at E; the broad-ended ones were simply moved along the paper while wet.

Despite my cheerful choice of colors, these could be used in a number of subtle or somber ways, to suggest natural forms or as design elements in an abstract.

Squeeze Bottles

I love the beautiful, endless linear effects possible with a squeeze bottle. You can buy paints in such bottles, use the eyedropper-tip of a bottle of liquid watercolor, or buy special squeeze bottles with fine tips to dispense whatever mixture you desire. These work well on a large watercolor; they allow plenty of arm movement, letting you develop beautiful rhythms.

I used a rich green dye color direct from the eyedropper tip for the body of this sample; the lighter lines are acrylic paint dispensed from the fine point of a squeeze bottle nozzle.

Stencils

The use of stencils with watercolor is a bit like stamping—anything goes, and you can create an amazing variety of effects, as uniformly or as loosely as you choose. Stencils may be bought commercially; they may be cut from tag board, plastic sheets, or even thin sheet brass. Many office supply stores carry interesting letter or number stencils that work well with an abstract concept.

Tom Lynch suggests tearing a loose stencil from paper and using it to protect areas of your work you don't want painted, then either sponging or spattering paint through the hole; it's a good idea.

I've even used my hand for a "stencil" or mask in this way; those fingers are always handy, and I'll wash.

I've used a number of stencils and nonstencils here as idea starters. Some are authentic Victorian stencils reproduced from a Dover Publications book (and used to decorate my living room!); others were office-supply store letters meant to label mailboxes and on the left, above, is my eraser shield again.

Oddly enough, I found that paint applied with a stencil brush didn't work as well as that painted on with a soft watercolor brush.

Natural Ingredients

The natural world is full of free "art supplies." You can get lively effects with a feather (our ancestors used quill pens; try the other end as a natural brush) or with a reed or a broken stick. Use leaves as painting tools; stamp with them, as we did on page 122, or use them as stencils to paint around. Look for mushrooms, weed-seed heads or other natural tools.

I used a red mulberry leaf to stamp with on the left; the green form and the thalo blue one used the same leaf. In the center, I used this same leaf to paint around, laying it directly on my paper and brushing all around the edge.

The fine line around the leaf shape and those just to the right were made with a stick found in my yard; I believe it was a Norway ma-ple. When I tired of the fine lines, I broke it off where the twig thickened to make the two heavier lines.

The loose, free thalo blue lines at right are wonderfully expressive. They were painted with a feather; the two long lines with the tip and the repeated lines at top were made with the spread-out filaments of the feather's barbs.

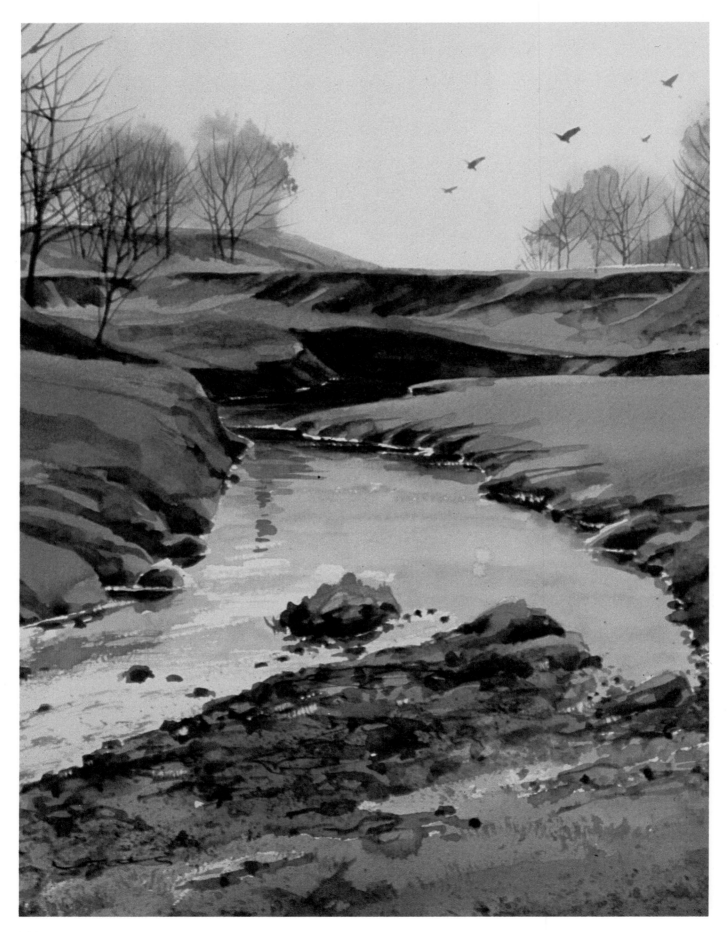

Techniques In Action

This section is a gallery of paintings and demonstrations intended to show you how one artist uses special techniques; you will be able to discern which are my personal favorites that I have found so useful that I employ them over and over again. Once you have looked through this book, practiced the techniques that especially appeal to you, and put them to work in your paintings, you may find you've chosen a different "bag of tricks." I hope I've offered a wide enough variety that you may find a fresh new road to explore. It doesn't have to be *my* road, but if we meet along the way I hope you'll stop and say hello.

"Early Spring"
15″ × 22″ (Collection Dr. James LaSalle)
Techniques used Scratching, spatter, drybrush, salt, lifting.

"Roots"
15" × 22"
Techniques used: scraping,
scratching, incising, liquid frisket,
sedimenting colors, spatter dot-
ting, waxed paper.

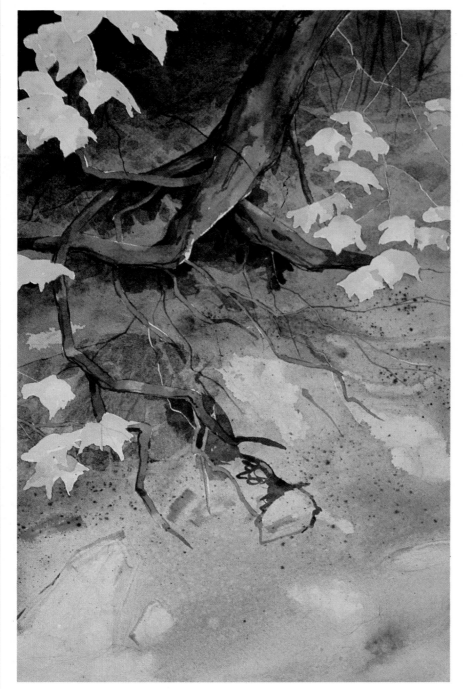

Before beginning to paint, I protect-
ed the leaves and roots with liquid
frisket to allow me to paint the pre-
liminary underwash as freely as
possible; I could have painted
around these areas had I chosen to
do so. When the mask was dry, I
wet down the entire sheet with my
clear-water sprayer, then using a
wide flat brush, painted in the grad-
ed cool-to-warm wash. To assure a
nice dark shadow area at the top, I
used thalo blue and burnt sienna,
then graded down to raw sienna. I
allowed "jewels" of pure pigment to
fall here and there for variety.

While this wash was still wet, I in-
cised in a few lines; since the paper
was wet and soft, the lines were
darker where the paper's fibers
were intentionally damaged.

I blotted large rock forms out of
this wet wash and scraped a few
areas back to a lighter value with
the end of my aquarelle brush, then
laid a layer of crumpled waxed pa-
per over the whole and went out to
lunch. While I was gone, textures
would form in the drying wash.

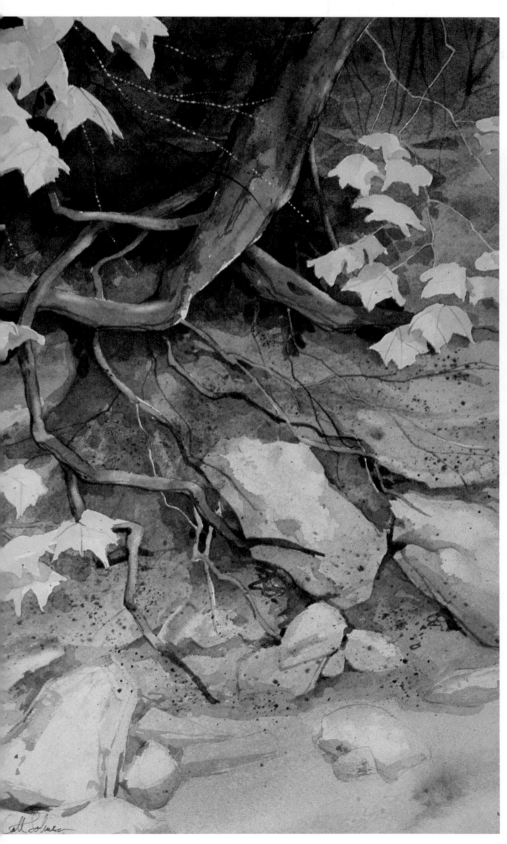

In this close-up foreground view, you can see the effects of blotting and scraping in the rocks; in some places (small rock at center right) the paper's surface was bruised, making a darker area along one side of the rock that suggests shadow.

In the finished painting, you can see that none of the special techniques pops out at you in an obtrusive way; I was careful to use those techniques that would blend well with each other and with my subject.

22″ × 30″ (Collection the Artist)
Techniques used: Paraffin wax,
hot press paper, "finger-painting,"
sedimenting colors, spatter, cut-
ting and peeling the paper's sur-
face, scraping, scratching, blot-
ting, fan brush, stamping.

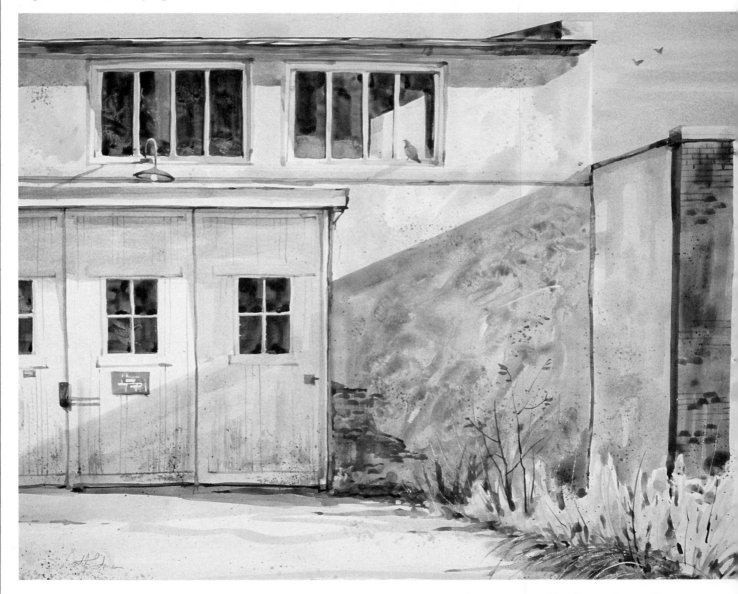

I was intrigued by the patterns of
light and dark, cast shadows, and
reflected lights on the varied tex-
tures of this ancient garage; hot
press paper seemed a perfect
choice to explore them. A fairly lim-
ited palette let me play with these
elements without their becoming
confusing.

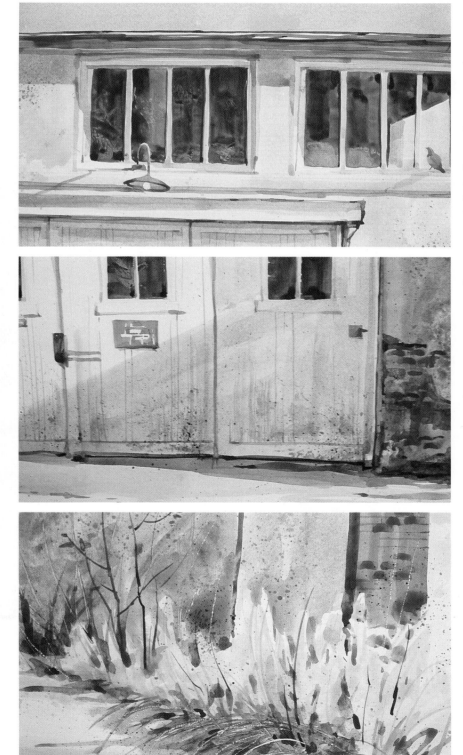

A bit of fingerpainting and blotting captured the feeling of the ancient glass in these small windows.

I didn't want to worry about painting around the light bulb in the fixture or even stopping to use a mask, so I painted right over the area where the bulb was to be. When it was thoroughly dry, I cut through the top layer of my paper with the tip of my X-Acto blade, then peeled this top pigmented layer away, revealing pure white paper underneath. The same trick was used to regain the light on the curved neck of the fixture.

My barbered fan brush was used to paint the ancient dirt at the bottom of the doors, using both linear strokes and short, jabbing strokes. Spatter added to the effect.

The bricks to the right of the door were stamped in place with the end of the bristles of a small (¼-in.) flat brush; windows in the old doors were blotted here and there for interest. To suggest the edge of the glass on the left, I scratched my paper's surface, when dry, with a sharp blade.

Texture was introduced in the clump of grass by scraping the pigment while still wet, then again as it dried to push some pigment out of the way. After it was thoroughly dry, I scratched and cut some more weeds out. Sedimenting colors suggest texture, and the hot-press surface encourages puddling. You can see the various pigment colors used for spatter throughout the painting.

"Jesse's Place"
15″ × 22″ (Courtesy *Missouri Life* Magazine)
Techniques used: pen and ink, watercolor washes, sedimenting pigments, spatter, bamboo penwork, fan brush.

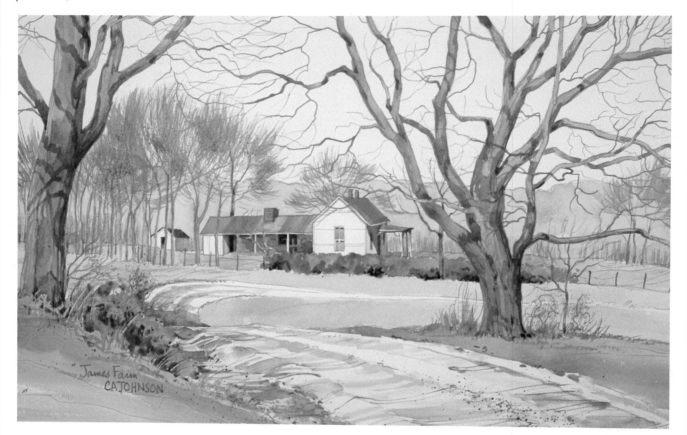

This is a painting of Jesse James' farm in rural Kearney, Missouri. I wanted to use a fresh approach. Rather than make one more watercolor portrait of the old place, I used a bamboo pen to draw the buildings, trees and other landscape elements with burnt sienna permanent ink.

When the drawing was thoroughly dried, I used loose watercolor washes, applied mostly with a flat brush to allow for some puddling for spontaneity. I chose a very nearly complementary color scheme, with the oranges and blues, to avoid overcomplicating the scene.

This close-up shows clearly the effects of the flat brush in the roof of the building, as well as the bright ink line that delineates the tree form. This made a nice vibration with the subtle sedimenting earth colors I chose for the tree itself. You can see some spatter was used to suggest foliage in the small weeds at lower right.

You can also see the effects of the sedimenting colors just where the road dips and turns, and in the form of the large tree on the left. In the background, I used the fan brush to depict the bare limbs and twigs of the trees surrounding the house. A bit of further spatter was added here for texture.

"Arrowrock Bridge"
15" × 20"
Techniques used: liquid frisket,
fan brush, spongework, sediment-
ing colors, blotting, spatter, paint-
ing with a palette knife.

This appears to be a fairly straight-forward painting. The techniques, I hope, are not obvious, and only add to the finished effect without distracting from it. I used a slightly rougher than normal cold press paper for this painting, to accentuate the dry-brush work used in the foreground. A fan brush was pressed into service here.

Before beginning to paint I protected the light tree forms and the trunk with its bright poison ivy (right), using liquid frisket and allowing it to dry completely. Then the foliage masses were laid in fairly wet-in-wet in the preliminary stages, allowing them to blend here and there.

As the washes began to dry I added darker ones of the same colors, adding spatter and some spongework for lacy variation. I blotted back a large area in the upper right to suggest a mass of foliage that would appear to come forward. When everything was dry, I painted the trunk up to the lighter form, then continued above it as if the trunk itself were behind the lighter mass. Some of the smaller limbs were painted with the tip of my palette knife instead of a brush for a varied, natural-looking line.

More spatter, dry brush, and some very subtle spongework suggest the foliage in the upper left. A few of the lightest limbs were scratched out with the tip of an X-Acto blade.

Sedimenting earth colors were used to give contrast in the bridge; this area was wetted and colors were allowed to blend freely and settle where they would.

"New Life"
15" × 22"
Techniques used: Plastic wrap, liquid frisket, scratching, clear-water spray, spatter, scraping, sedimenting colors, washing back, blotting.

I wanted to concentrate attention on the cut stump and the indomitable sprout; this is a powerful resurrection symbol for me. The forest beyond was a tapestry of leaves; I didn't want to get caught up in painting the details, so I decided to suggest them instead with plastic wrap.

First, I masked out the stump, the tree sprout, and selected light-struck weeds and grasses at the edge of the hill. Frisket was applied with a brush, with my palette knife in the fine lines (by using the sharp edge), and spattered on with my stencil brush.

When it was dry, I mixed a rich wash of thalo green, thalo blue, and burnt umber and laid it in quickly with a wide, flat brush. While it was still quite wet, I laid crumpled plastic wrap over the whole area, weighed it down and allowed it to dry for a few hours. Then I removed the plastic wrap and mask.

A juicy wash of sap green and raw sienna was brushed on to the grassy areas of the foreground, laying in darker values where I wanted to suggest deeper grass or form in the hill itself. Before the wash dried but after it lost its first wet shine, I scraped back into the pigment with the handle of my aquarelle brush to suggest individual grass blades. Spatter and a little dry-brush work with my fan brush finished this area.

In this detail shot, you can see how sedimenting colors worked well in the top of the stump, as well as in the shadowed sides.

The background just beyond the stump seemed too harsh and distracting; if I had lifted the plastic wrap before it had dried in place, the effect would have been softer—but all was not lost. I protected the hill, already painted, and sprayed the background with clear water. While it was still quite wet, I flooded in some soft shadows, using thalo green and sepia umber. It succeeded in softening this area somewhat.

This is the finished painting. I introduced as much color as I could to keep this essentially green painting lively.

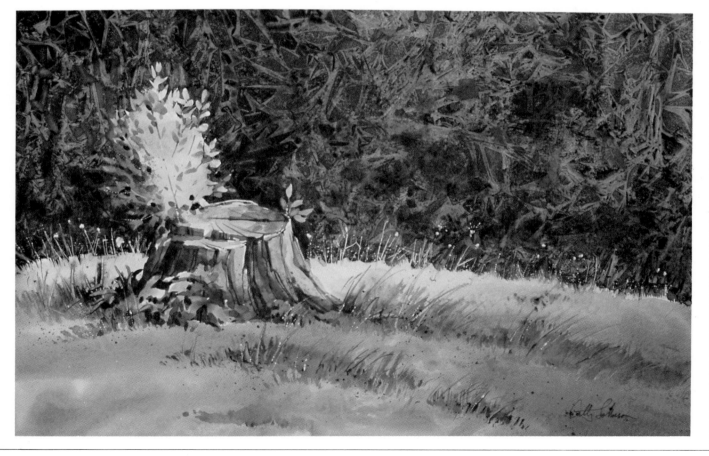

"Graffiti"
15" × 22" (Collection AT&T)
Techniques used: Hot press paper, masking-tape masks, crayon work, liquid mask, sedimenting colors, salt, stamping, spatter, lifting.

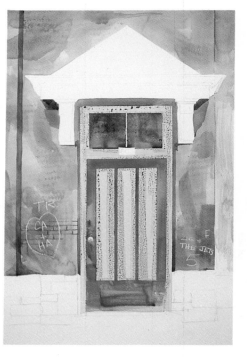

In Step 1 I've sketched in my composition with a #2 pencil and masked the areas of the light door jamb and the door's glass with masking tape. I laid the tape over the pencil drawing and cut through to the pencil line visible below (being careful *not* to cut through to my paper). Excess tape was then peeled away. I wanted to be able to paint the blue door freely, so I protected the knob with liquid frisket, which I also used on the house numbers above the door.

I chose subtle colors for the graffiti; I wanted the overall color of the painting to be subdued.

In Step 2 I have roughly brushed in the pigments chosen for the bricks—mostly brown madder alizarin and ultramarine blue, with a bit of burnt sienna added for extra warmth. The paint was applied with a large flat brush, and puddling was encouraged.

When the first wash was dry, I added the blue door all in one go, with the warm burnt umber in the lower panel, the windows above the door, and the long line to suggest a jog in the brickwork to the left. A bit of texturing was added with the back of a synthetic sponge dipped in a stronger mixture of the same pigments used for the brick. Shadows were added to the brick under the overhanging porch and here and there to suggest the bricks without painting each one like a portrait.

In this detail shot you can see the effects of the puddled washes and the water-resistant crayons. Notice how the pigments separated on the blue door to suggest great age.

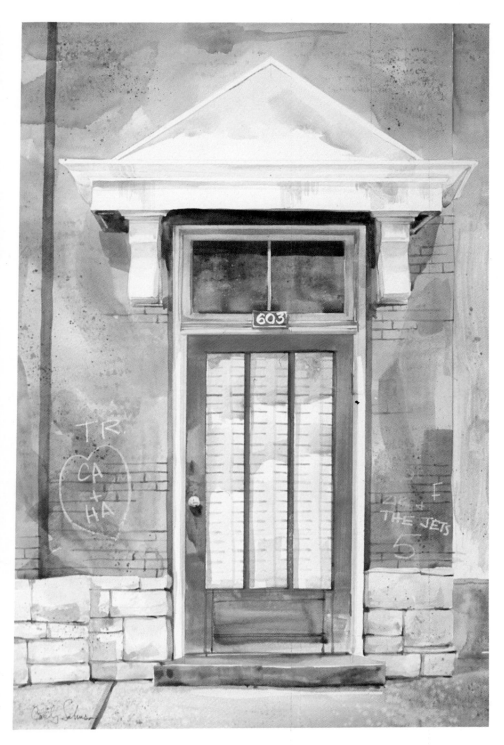

In the completed painting, the masking tape has been removed and the details of the venetian blinds painted in with a flat brush.

Spatter further textures the brick, and details have been added to the porch overhang, using a flat brush and a light touch; I didn't want to overpaint this area. I lifted a bit of detail from the underside of the porch roof with a damp brush, then blotted away the loosened pigment.

I painted the sidewalk with a mixture of ultramarine and burnt umber, further textured with a little salt while it was still damp. Spatter into this damp wash also suggested the sandy texture of cement.

Notice the doorknob; I liked the effect the pigments made over the liquid mask so well I simply didn't remove it; I couldn't have painted it better myself!

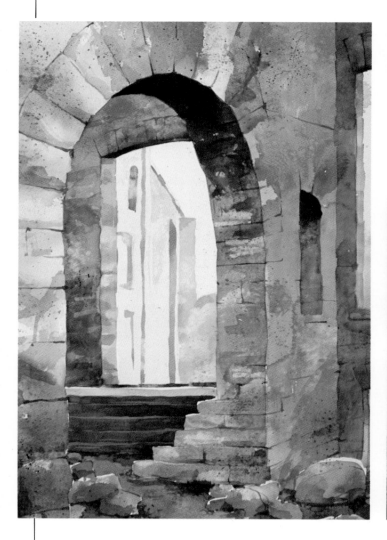

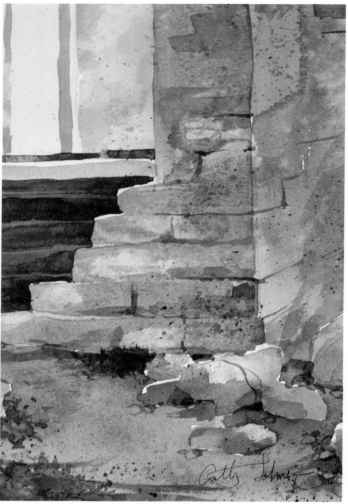

These old stones required a lot of texturing techniques—too much sameness here would have been deadly. Warm and cool colors were played off each other for interest as well as to suggest the varied planes of the old castle.

In the detail shot, above, you can see where I've scraped pigment back to a lighter value to define the stones of the central upright. Near the bottom of the arch, I used blotting to achieve a similar effect.

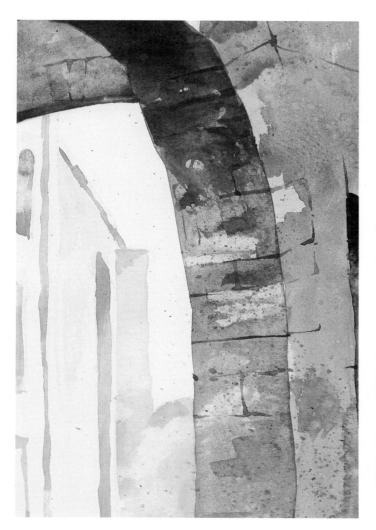
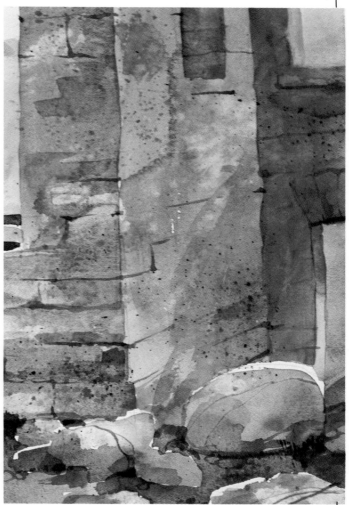

Scraping, blotting, spatter and a little salt all give texture to the stonework. To suggest the cracks in the old stones that have fallen to the ground, I incised darker lines into them while the washes were still quite wet (visible in the detail, bottom right). Notice the bright "jewels" of brown madder alizarin used to give them sparkle. Positive and negative spatter and salt are all visible as texturing efforts in the center.

"The Brass Knob"
15″ × 22″ (Collection AT&T)
Techniques used: Hot press paper, dry brush, positive and negative spatter, clear-water spray, inscribing, scraping, salt and lifting, scratching, fingerpainting, sedimenting colors.

This painting actually used a lot of special techniques, but they don't detract from the finished work; I try hard to keep it that way. In the final painting, you can see the variety of tricks were fairly well balanced throughout and kept very subtle. I was actually amazed to count eleven tricks used in one painting—I didn't think it was possible.

You can see the effects of sedimenting colors in the shadows. The two long scratches on the right were incised into my wash while wet, bruising the paper's fibers. Below, I lifted the light-struck edges of the nail holes with a brush and clear water and blotted away excess pigment.

Dry-brush work was added to suggest wood grain, mostly using my barbered fan brush (trimmed to make it a bit irregular).

In the doorknob itself, successive washes were dry-brushed on and fingerpainted for added texture.

You can see the effects of salt in the dark glass of the window. I used a rigger brush to paint the reflected tree limbs, and when the window washes were dry, I went back in with my sharp craft knife to scratch out a sparkly line at the bottom of the glass.

I didn't get the shadow washes dark enough on the first go, so I went back in with my clear-water sprayer and dampened the surface again. While it was still glossy wet I added another layer of shadow for a soft-edged look.

"Harris in the Barn Door"
15″ × 22″ (Collection the Artist)
Techniques used: Hot press paper, puddling, scraping, stamping.

This painting of my husband was done on hot press paper, which allowed me to explore a number of special techniques. First and most important, of course, was composition; I paid special attention to negative spaces, keeping them as interesting and varied as possible.

You can see the effects of puddling on the extremely slick-surfaced paper and of scratching through the dry wash with the tip of my craft knife. In the background, I've suggested the ancient wire over the lower half of the window with my fan brush.

You can also see the stamping technique used to create texture in the jeans; I made my preliminary blue wash quite wet, then blotted it with a paper towel laid flat on my paper's surface to take advantage of the texture of the towel itself. Subsequent washes explain shadow areas. Again, you can see scratching and a bit of scraping in the straw on the barn floor.

This is a favorite cat, curled into a pile of afghans—it was too good not to paint. I used the edge of my flat brush to stamp the various shapes in the afghans for a nice tooled effect. The spatter simply suggests the reality of the couch the cat was lying on; I didn't want to go into any more detail than that

and the directional lines that serve to give form to the otherwise invisible sofa.

I scraped the handle of my aquarelle brush into the wet washes of Ida Mae's fur to suggest the lighter guard hairs, and when everything was dry, I scratched her whiskers out with a sharp blade.

"Someone I Love"
15" × 22" (Collection the Artist)
Techniques used: Hot press paper, sedimenting colors, spatter, scratching.

I wanted to try a portrait of my husband in a favorite pose, and didn't want to risk overworking it, so I chose hot press paper to work on. After drawing a careful road map of his physiognomy, I began laying in nice, loose, puddly washes, working from light to dark.

In this detail shot, you can see how I've used the background washes to define the right side of his face. I painted around the lights of his glasses and the light-struck planes of forehead, chin, and nose; otherwise I let the paint puddle to create the shadows and curves of his face.
 When everything was dry, I added the details of his hair by scratching through to white paper with the tip of my X-Acto blade.

The kitten was completed in the same three-step process of washes: light, medium, and dark for small details. Again, when everything was dry, I scratched back the tiny light-struck hairs of his ears and eyebrows.

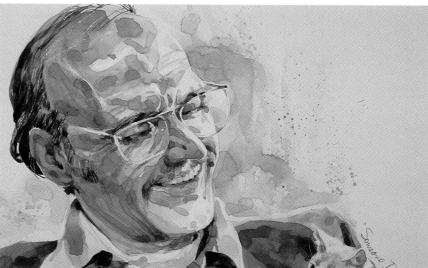

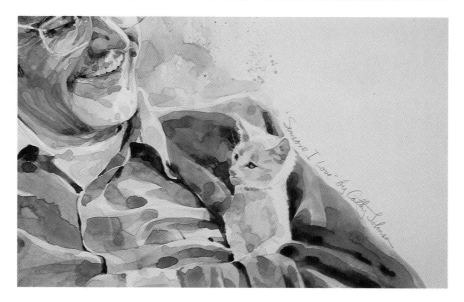

"Coming Down"
15 × 22" (Collection AT&T)
Techniques used: plastic wrap,
spatter, sedimenting pigments,
felt-tip pen, spongework.

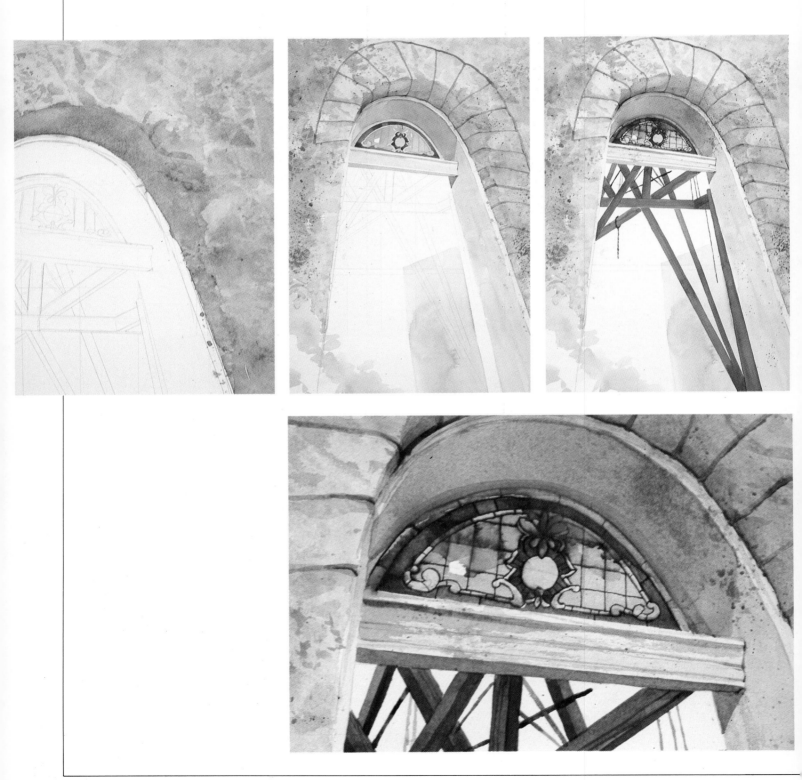

I had wanted to paint this old church being demolished in the Westport area of Kansas City for a long time; I did research work for the painting fifteen years ago! Finally, technique and timing all came together and I decided to give it a go.

Step 1 details the first washes, which were put down very loosely and mixed on my paper surface instead of on the palette. Plastic wrap was crumpled and pressed into the wash surface to suggest the roughness of the old limestone. This wrap was lifted and repositioned several times for additional texture.

Now in Step 2, I've added some subtle spongework and spatter to add to the aged effect. I've begun the first washes in the remains of the stained-glass window and added the first wash to the vines at left.

In Step 3, I've gone back with a water-based felt-tip pen to draw in the lead of the window, knowing it will spread in a lively way when wet. The frame is in place around the window, with some additional texturing suggested with spatter and a hint of dry brush. The beams of the old building are exposed to the elements.

In the detail shot, bottom left, you can see the wonderfully wild effects of black felt-tip lines when wet with a brush and clear water. It gives just the right aged effect here with no further working over.

In the finished painting you can see the subsequent washes in the vine foliage and the twigs that make it real. Here, too, a little spatter was used for texture.

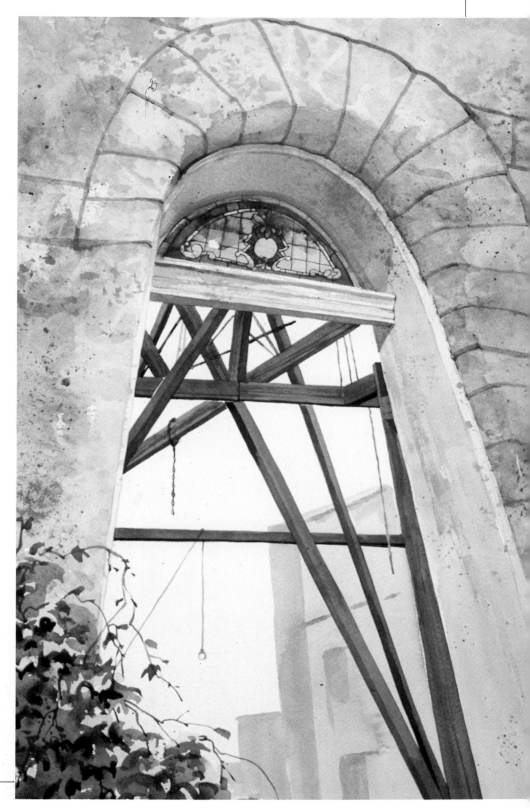

"Gargoyle's Cauldron"
15″ × 22″ (Collection AT&T)
Techniques used: Salt, scratching, cutting, puddling, sedimenting colors, spatter.

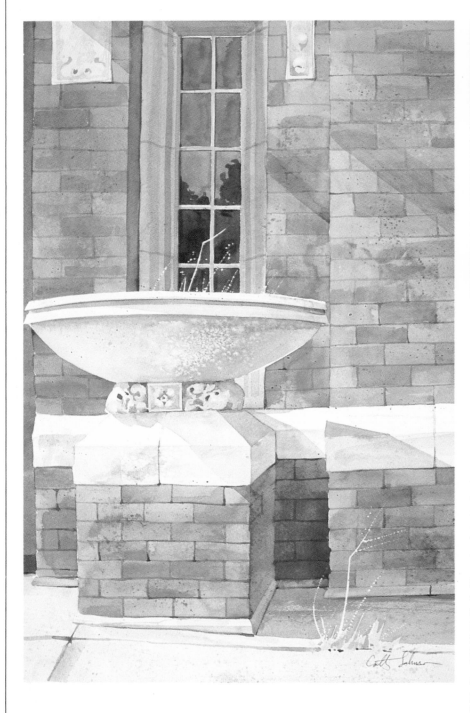

I wanted the effect to be one of great subtlety in this painting, so I chose a strictly limited palette. I almost got carried away with detail and did a portrait of brick, but at least it's not garish!

The effects of light and shadow are the real subjects here; I loved the reflected lights on the bottom of the "cauldron."

I used a flat brush to make the paint puddle in the windows; they were painted with a single stroke each. Details of reflections were added later, when everything was dry. Spatter was used to lightly texture the bricks, and blotted here and there for variation.

In the detail shot you can see the effects of sedimenting colors and salt applied at just the right time; my wash had barely begun to lose its shine. I allowed the salt to dry thoroughly before brushing it away. The dead weeds sprouting from the cauldron were scratched into my paper when it was dry; the one bent weed was carefully cut through the upper layer and peeled away for a more distinct effect.

"Poland Chinas"
15″ × 22″
Techniques used: stamping, fingerpainting, spatter, hot press paper, sedimenting pigments, liquid frisket, drybrush.

This was an old barn near where I used to live; I always liked to pass the ramshackle buildings on my way into town. Only the central building still stands; I'm glad I got to do this painting before it collapsed.

I chose hot press paper for the variety of textural effects possible; I knew I'd need them here.

You can see that the foreground was handled fairly directly; large clumps of dead grass were painted with vigorous upward strokes of my loaded fan brush; puddles of burnt umber and sepia umber suggest clods of earth. Some I touched with my finger to give a bit of texture. Spatter completed this area.

In the detail shot, you can see how the sedimenting colors (applied with a ½-in. flat brush) puddled and separated to suggest the individual boards as well as their warped nature. Very little additional work was needed in the form of dry-brush work to suggest the barn itself.

I protected the bare tree at right with liquid mask before starting to paint; I wanted to keep it lighter and warmer than the background trees. When I laid them in I used a flat brush and sedimenting colors, tipping my board a bit to encourage puddling, to give them a sense of volume and depth.

The pigs that give this painting its name were painted with a single stroke each; shadow and dimension was suggested by the puddling possible on hot press paper. I painted in the far fence posts and the corral in the background with the edge of my flat brush, using it as a stamping tool. The fan brush, used quite dry, made the rough field just to the right of the fence.

"Arches"
15" × 22" (Collection AT&T)
Techniques used: liquid frisket, blotting, printing, incising, spatter, waxed paper, sedimenting colors.

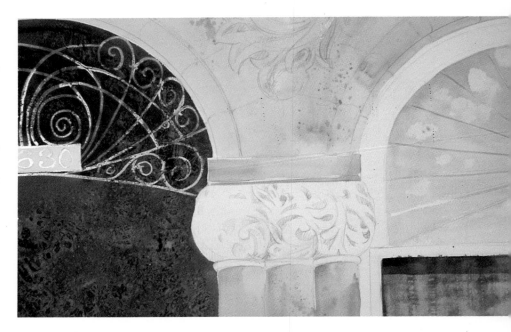

I liked these double arches, so similar and yet so different; I drew their shapes carefully by scribing around an old dinner plate. Before painting, I protected the lacy ironwork in the left-hand arch with liquid mask.

Much of the texturing was done while the washes were still wet or becoming only damp. To suggest the spokes in the wheel-like window at right, I incised lines into my wet wash—they bruised the paper, making it absorb more pigment and leaving darker lines. Between the spokes, I blotted to give variation to the antique, wavy glass.

The large dark wash in the doorway was painted with thalo blue and burnt umber; while it was still very wet I laid crumpled wax paper into the puddle and weighted it down for a while, but not until fully dry.

The stonework itself was painted with raw sienna and a touch of cobalt blue, applied in variable amounts and spattered while still damp.

In this detail shot you can see the attention given the ironwork; after the dark wash had dried, I removed the liquid mask and painted the first burnt sienna wash over the dark area and the ironwork at the same time—this reduced the "cutout" look of a masked area. Then details were added when the area dried again, and an additional shadow wash was pulled from the top down over part of the grille.

You can see also that additional shadows and spatterwork were added to the stone to give the suggestion of texture.

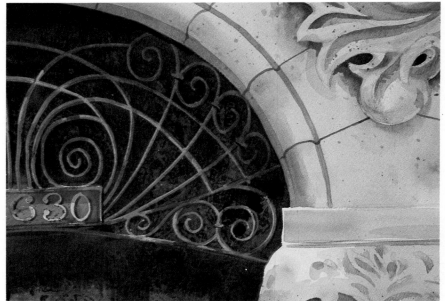

Here, more detail work in the form of dry brush and spatter as well as flat-brush puddles was added to finish the right-hand window. Contouring the fancy, carved stonework was accomplished in three steps: the original shadow wash, light details, and sharp accents.

In the finished painting, you can see the balance of details on both sides of the work. The fancy carving is, of course, my center of interest, but I wanted enough detail work to give the eye something to do as it traveled over the picture plane. Special techniques let me accomplish that without overworking.

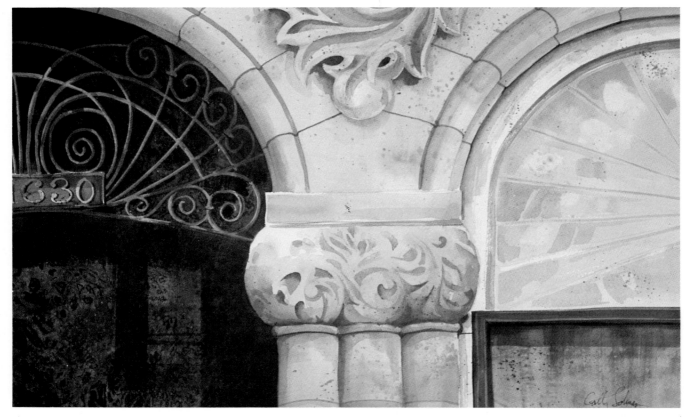

"Autumn Stream"
and "Old Stumps"
3″ × 5″
Techniques used:
Colored pencil.

These are two small, on the spot sketches done with a wax-based Prismacolor pencil. Later, at home, I added the watercolor washes from memory. I find this helps me to develop my color sense.

Before beginning to paint, I made a variety of marks with a paraffin wax candle; some are quite narrow and made with an edge, while some are wide, made with the broad side.

Then loose washes of burnt sienna, burnt umber and manganese blue were flooded over the surface; the wax repelled the paint, leaving light streaks and planes. Positive and negative spatter added to the textures, here, but the most noticeable effect is made by drawing a croquill pen nib, loaded with first sepia, then black India ink through the wet washes. Where the washes had begun to dry (upper right) the lines are simply lines; where it was still fairly wet the lines exploded into interesting squiggles, fissures and cracks in the rock face. In this instance, the sepia explosions were much more active than the India ink; this depends more on the wetness of the underwashes than on the inks themselves, I believe, since India ink will also "go wild" on occasion.

Tree limbs were also "painted" with India ink and a croquill pen. The vulture flying low before the cliff face "took" over the repellent nature of the wax lines only by repeated re-statements; I simply built up a thick enough layer that it stayed put!

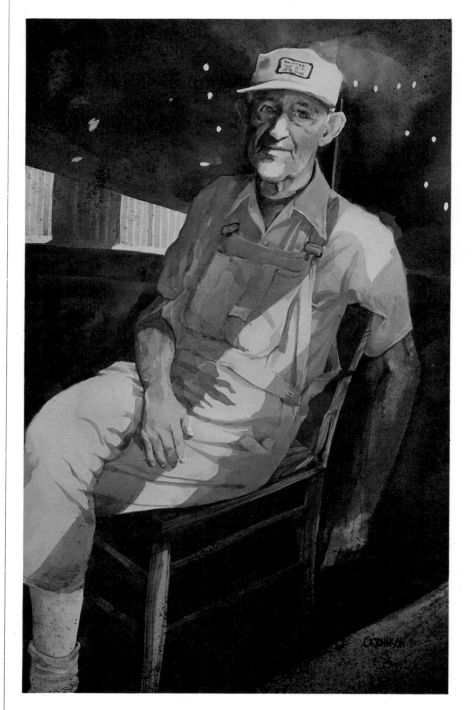

This was a fairly straightforward painting; liquid frisket was employed to preserve the bright spots where sunlight showed through the nail holes in the old tin building. Because I wanted to let the lower part of the figure fade into lesser importance, I spattered profusely over all of the lower area to darken and blend these elements together. For a final bit of spark, I scratched light-struck hairs out of Ern's beard and sideburns with the tip of my X-Acto blade. I'm glad Ern's grandson bought this for his mother—I had hoped someone in the family would buy it, but I painted it for my own pleasure.

"Sorghum Making"
15″ × 22″ (Private collection)
Techniques used: Clear water
spray, spatter, blotting liquid dye
colors.

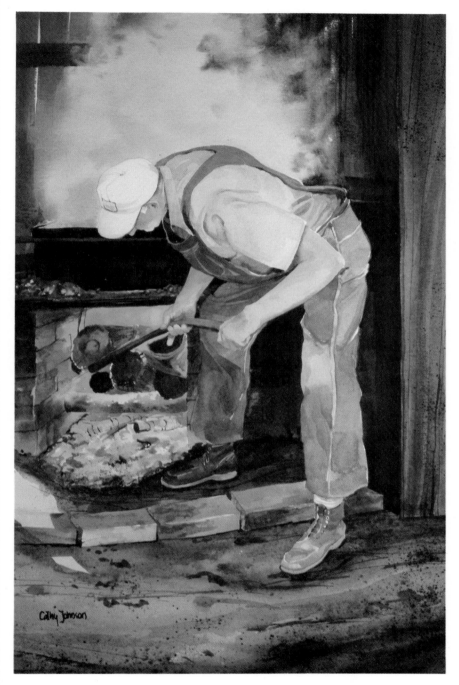

This painting was included to show
the effects of painting back into an
area that has been wet with clear
water, as in the steam from the
boiling sorghum. This is a nice
softening technique, useful in an
abstract way as well to suggest
smoke, clouds, what have you. Liq-
uid dye watercolors were used in
the fire for their intensity.

This is Old Ern again; I've blotted
both his chin and his knee while
the washes were damp to lighten
them. The foreground was liberally
spattered to suggest the rough,
dark earth.

"Doorway"
15″ × 22″ Private Collection
Techniques used: Hot press paper, scraping, fingerpainting.

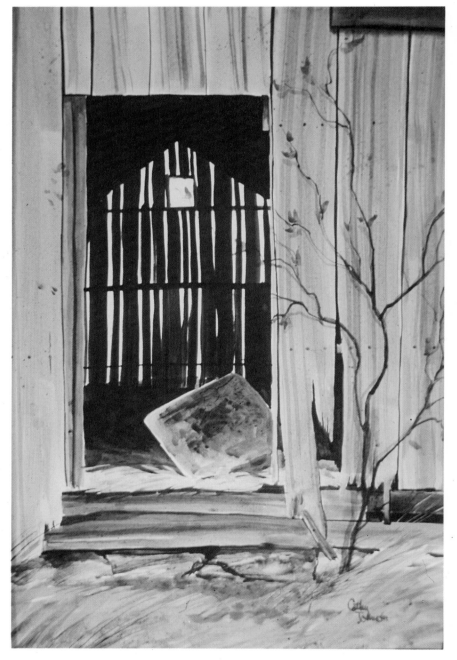

Here, the smooth texture of the paper let me make my own special effects. I scraped back some weeds while the washes were still wet, used a bit of salt and spatter for texture in the rocks, and went wild on the old stoveboard propped up in the barn door; I laid in the thick washes and fingerpainted them.

"Calaboose"
11″ × 14″ (Collection Harris
Johnson)
Techniques used: Hot press pa-
per, puddling with a flat brush,
fan brush work, sedimenting col-
ors, spatter.

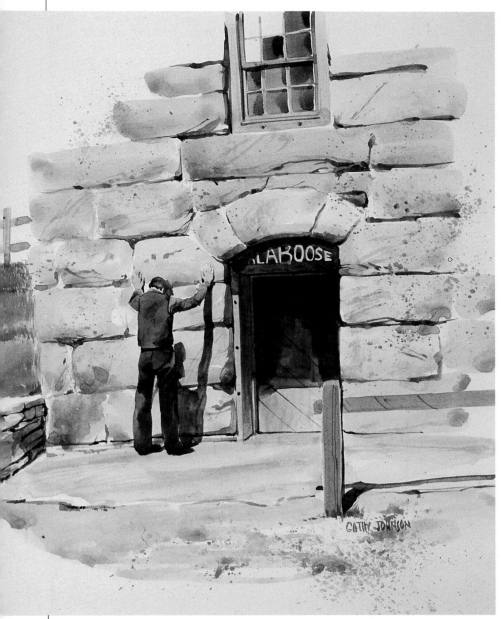

The puddles created by using a flat
brush on hot press paper contrib-
uted to the sense of volume in the
huge sandstone blocks of the old
jail as well as in the windowpanes
above. I chose sedimenting colors
for a rocky texture and accentuated
the effect with variecolored spatter.
A little drybrush work in the stones
and in the nearby grass completed
this vignette.

INDEX

Other Art Books from North Light

Graphics/Business of Art

An Artist's Guide to Living By Your Brush Alone, by Edna Wagner Piersol $9.95 (paper)

Artist's Market: Where & How to Sell Your Graphic Art, (Annual Directory) $18.95 (cloth)

Basic Graphic Design & Paste-Up, by Jack Warren $12.95 (paper)

Color Harmony: A Guide to Creative Color Combinations, by Hideaki Chijiiwa $14.95 (paper)

Complete Airbrush & Photoretouching Manual, by Peter Owen & John Sutcliffe $23.95 (cloth)

The Complete Guide to Greeting Card Design & Illustration, by Eva Szela $24.95 (cloth)

Design Rendering Techniques, by Dick Powell $27.95 (cloth)

Dynamic Airbrush, by David Miller & James Effler $29.95 (cloth)

Getting It Printed, by Beach, Shepro & Russon $29.50 (paper)

The Graphic Artist's Guide to Marketing & Self Promotion, by Sally Prince Davis $15.95 (paper)

The Graphic Arts Studio Manual, by Bert Braham $22.95 (cloth)

How to Draw & Sell Cartoons, by Ross Thomson & Bill Hewison $15.95 (cloth)

How to Draw & Sell Comic Strips, by Alan McKenzie $18.95 (cloth)

How to Understand & Use Design & Layout, by Alan Swann $22.95 (cloth)

Illustration & Drawing: Styles & Techniques, by Terry Presnall $22.95 (cloth)

Marker Rendering Techniques, by Dick Powell & Patricia Monahan $32.95 (cloth)

The North Light Art Competition Handbook, by John M. Angelini $9.95 (paper)

Presentation Techniques for the Graphic Artist, by Jenny Mulherin $24.95 (cloth)

Studio Secrets for the Graphic Artist, by Graham et al $27.50 (cloth)

Type: Design, Color, Character & Use, by Michael Beaumont $24.95 (cloth)

Watercolor

Getting Started in Watercolor, by John Blockley $17.95 (paper)

Make Your Watercolors Sing, by LaVere Hutchings $22.95 (cloth)

Painting Nature's Details in Watercolor, by Cathy Johnson $24.95 (cloth)

Watercolor Interpretations, by John Blockley $19.95 (paper)

Watercolor—The Creative Experience, by Barbara Nechis $16.95 (paper)

Watercolor Tricks & Techniques, by Cathy Johnson $24.95 (cloth)

Watercolor Workbook, by Bud Biggs & Lois Marshall $18.95 (paper)

Watercolor: You Can Do It!, by Tony Couch $24.95 (cloth)

Mixed Media

Catching Light in Your Paintings, by Charles Sovek $16.95 (paper)

Colored Pencil Drawing Techniques, by Iain Hutton-Jamieson $22.95 (cloth)

Creative Drawing & Painting, by Brian Bagnall $29.95 (cloth)

Drawing & Painting with Ink, by Fritz Henning $24.95 (cloth)

Exploring Color, by Nita Leland $26.95 (cloth)

Keys to Drawing, by Bert Dodson $21.95 (cloth)

The North Light Handbook of Artist's Materials, by Ian Hebblewhite $24.95 (cloth)

The North Light Illustrated Book of Painting Techniques, by Elizabeth Tate $26.95 (cloth)

Painting Seascapes in Sharp Focus, by Lin Seslar $24.95 (cloth)

Painting with Acrylics, by Jenny Rodwell $19.95 (cloth)

Pastel Painting Techniques, by Guy Roddon $23.95 (cloth)

The Pencil, by Paul Calle $16.95 (paper)

Putting People in Your Paintings, by J. Everett Draper $22.50 (cloth)

Tonal Values: How to See Them, How to Paint Them, by Angela Gair $24.95 (cloth)

You Can Learn Lettering & Calligraphy, by Gail & Christopher Lawther $15.95 (cloth)

To order directly from the publisher, include $2.00 postage and handling for one book, 50¢ for each additional book. Allow 30 days for delivery.

North Light Books
1507 Dana Avenue, Cincinnati, Ohio 45207
Credit card orders call
TOLL-FREE
1-800-543-4644 (Outside Ohio)
1-800-551-0884 (Ohio only)
Prices subject to change without notice.